C0-BQT-554

PIOUS JOURNEYS

The Catholic
Theological Union
LIBRARY
Chicago, Ill.

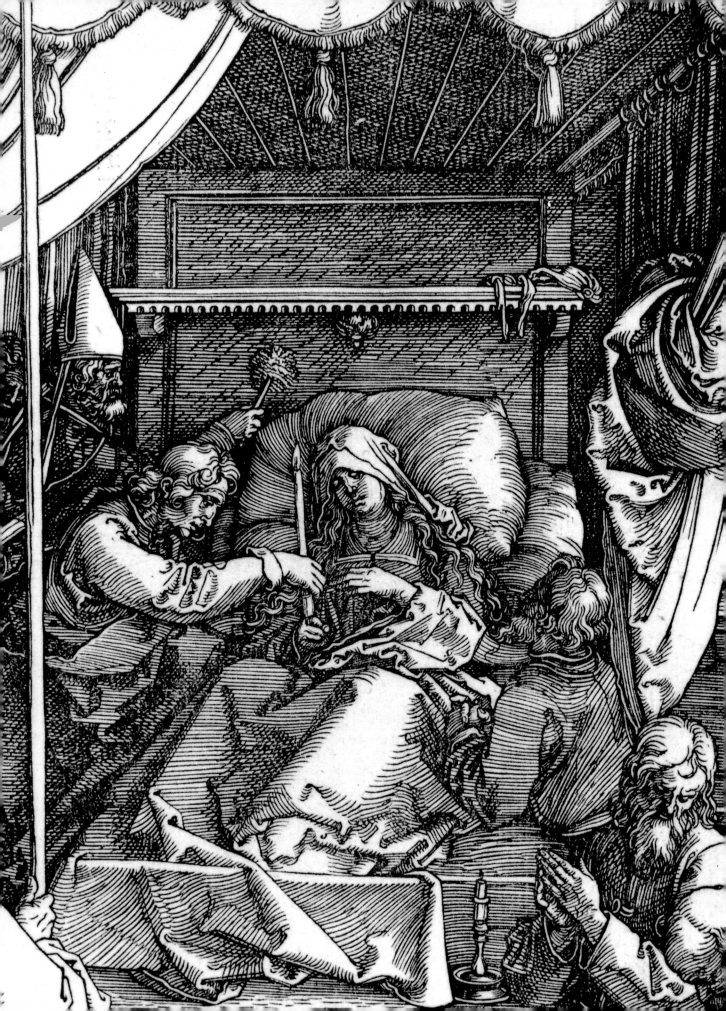

PIOUS JOURNEYS

CHRISTIAN DEVOTIONAL ART AND PRACTICE IN THE LATER MIDDLE AGES AND RENAISSANCE

Linda Seidel

WITH CONTRIBUTIONS BY

Jennifer Sarene Berg, Sienna Brown, Wen-shing Lucia Chou,
Melati Lucille Granucci, Todd Anthony Komoroski, Stephanie Leitch,
Ann Marie Lonsdale, Risham Majeed, Anna Ohly, Pamela Raboy,
Stefania Rosenstein, and Matthew Shoaf

WITHDRAWN

The Catholic
Theological Union
LIBRARY
Chicago, Ill.

THE DAVID AND ALFRED
SMART MUSEUM OF ART
THE UNIVERSITY OF CHICAGO

Catalogue of an exhibition at
The David and Alfred Smart Museum of Art
The University of Chicago
14 March–10 September 2000

Copyright © 2001
The David and Alfred Smart Museum of Art
The University of Chicago
5550 South Greenwood Avenue
Chicago, Illinois 60637
(773) 702-0200
www.smartmuseum.uchicago.edu
All rights reserved.

This catalogue was funded by a multiple-year grant from the
Andrew W. Mellon Foundation to the Smart Museum to encour-
age interdisciplinary use of its collections by University of
Chicago faculty and students both in courses and through the for-
mat of special exhibitions.

Design and typesetting: Joan Sommers Design, Chicago
Production and Copy Editor: Elizabeth Rodini
Copy Editor: Britt Salvesen
Printed in Hong Kong by C & C Offset Printing Co., Ltd.

Cover: Artist Unknown, Italian, Sienese School, *The Crucifixion*,
circa 1350, 1973.40 (Cat. no. 11)

Reverse Cover: Albrecht Dürer, *Sudarium Displayed by Two Angels*,
1513, 1979.1 (Cat. no. 47a)

Photography Credits: Photography by Tom van Eynde unless
otherwise noted; figs. 2, 6, 8, 9, 17, 26, 33, 34, 45, and 47,
Smart Museum Archives; fig. 1, The Toledo Museum of Art;
figs. 4, 22, 23, 25, 27, 28, 29, 32, 37, 40, 42, and 50, Courtesy
of the Newberry Library, Chicago; figs. 15 and 24, Courtesy of
the Department of Special Collections, University of Chicago
Library; fig. 18, The Minneapolis Institute of Arts; fig. 20, The
Walters Art Gallery, Baltimore; figs. 35 and 39, Courtesy of The
Martin D'Arcy Museum of Art, Loyola University of Chicago.

Library of Congress Catalog Card Number: 00-133462

ISBN: 0-935573-30-5

CONTENTS

FOREWORD AND ACKNOWLEDGMENTS

The exhibition *Pious Journeys: Christian Devotional Art and Practice in the Later Middle Ages and Renaissance* was organized by Professor Linda Seidel, and was shown at the Smart Museum from March 14 to September 10, 2000. This catalogue documents that exhibition and the work of Professor Seidel's students, who were involved in many phases of the project. *Pious Journeys* explored the ways that the visual and material arts shaped Christian worship in Europe, with an emphasis on the experiential elements of religious practice. The range of this exhibition was broad, not only chronologically and geographically, but also in terms of the sorts of objects included. By bringing together altarpieces and devotional jewels, illuminated books of hours and liturgical vestments, *Pious Journeys* shed light on larger questions dealing with the nature of religious practice and the shape of religious observance.

This exhibition was one in a series of projects sponsored by a grant from the Andrew W. Mellon Foundation that fosters interaction between University of Chicago faculty and students and the Smart Museum. It originated in discussions with Professor Seidel, Coordinating Curator for Mellon Projects Elizabeth Rodini, former Mellon intern Christine L. Roch, and art history graduate students Stephanie Leitch, Stefania Rosenstein, and Matthew Shoaf. Together, these participants studied the museum's permanent collection, defined the exhibition's principal themes, and researched and wrote the exhibition labels and catalogue text. In the spring of 2000, Professor Seidel taught a course on late medieval pilgrimage that used the exhibition as one of its central study tools. In addition to examining a range of primary and secondary written sources, class participants read the essays by Leitch, Rosenstein, and Shoaf published here and used them as models for investigating objects in the exhibition more closely and in the context of the course's larger themes. Their writings have been brought together in the catalogue's final essay, which is at once a reflection on the course and exhibition, and a compilation of the students' own responses to the material traces of late medieval and Renaissance piety.

We are grateful to Professor Seidel for taking on this project with her usual enthusiasm and energy, and particularly for her strong commitment to the pedagogic aims of the Mellon projects. She has pushed the model for student-faculty-museum interaction in a valuable new direction, a task that put great demands on her as a scholar and teacher. The three scholars who visited campus in connection with her course were an important part of this program. Professor Seidel joins me in thanking Patrick J. Geary, formerly Professor of History at the Medieval Institute, University of Notre Dame, and now Professor of History at UCLA; Peggy McCracken, Associate Professor of French at the University of Michigan; and Paul Saenger, George A. Poole III Curator of Rare Books at the Newberry Library in Chicago for their participation.

Professor Seidel's graduate students, the authors of the first three essays published here, also deserve special mention, as their work not only documents the exhibition but was also

critical to its conceptualization and realization. Several other art history graduate students contributed to this project, including Georgi Parpulov, who consulted on the Museum's Byzantine and Early Christian holdings, and Lisa Deam, who researched the manuscripts that were lent to this exhibition. Finally, as Professor Seidel notes in her introduction to the final essay, all of the students in her course contributed to the success of this exhibition through their interactions with and responses to the material in it. Among these, we would like to thank those who participated in writing the undergraduate essay: Jennifer Sarene Berg, Sienna Brown, Wen-shing Lucia Chou, Melati Lucille Granucci, Todd Anthony Komoroski, Ann Marie Lonsdale, Risham Majeed, Anna Ohly, and Pamela Raboy. The staff of the Smart Museum worked hard to make this exhibition a success. In particular, we thank Mellon museum interns Christine L. Roch, Stefania Rosenstein, and Simone Tai, as well as Senior Curator Richard A. Born, Registrar Jennifer Widman, Preparator Rudy Bernal, and Preparation Assistant Tim Duncan.

Several institutions and individuals deserve special mention for enriching this exhibition with a selection of beautiful and precious objects from their collections. For the loan of important manuscripts and printed books, we are grateful to the Department of Special Collections at the University of Chicago's Joseph Regenstein Library, including Valarie Brocato, Exhibitions and Conservation Supervisor, and Curator Alice D. Schreyer, whose ongoing support for our various Mellon-sponsored exhibitions deserves special mention; and to the Newberry Library, Chicago, where we have once again been generously assisted by Project Assistant Susan Summerfield Duke, Book and Paper Conservator Susan Russick, and Associate Librarian Mary Wyly, and where we received further support and direction from Paul Saenger. We also offer our thanks to the Martin D'Arcy Museum of Art at Loyola University in Chicago, Assistant Director Kate Lucchini and Director Sally Metzler; the Minneapolis Institute of Arts, Associate Curator Catherine Futter and Evan M. Mauer, Director and President; and the Toledo Museum of Art, Registrar Patricia J. Whitesides and Director Roger Berkowitz.

Finally, we thank Angelica Zander Rudenstine, Senior Advisor for Museums and Conservation at the Andrew W. Mellon Foundation, who has provided invaluable assistance and guidance throughout the tenure of this grant. As always, our Coordinating Curator for Mellon Projects Elizabeth Rodini has skillfully guided this project to realization. Her experience and expertise have made all the difference, and we are very grateful to her.

KIMERLY RORSCHACH
Dana Feitler Director
Smart Museum of Art

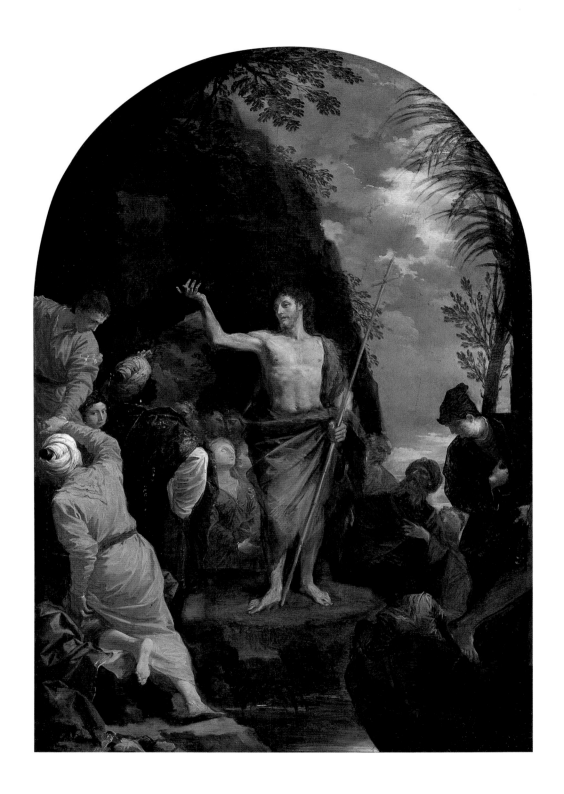

PLATE 1

Donato Creti

Saint John the Baptist Preaching,

circa 1690–1710

(Cat. no. 12)

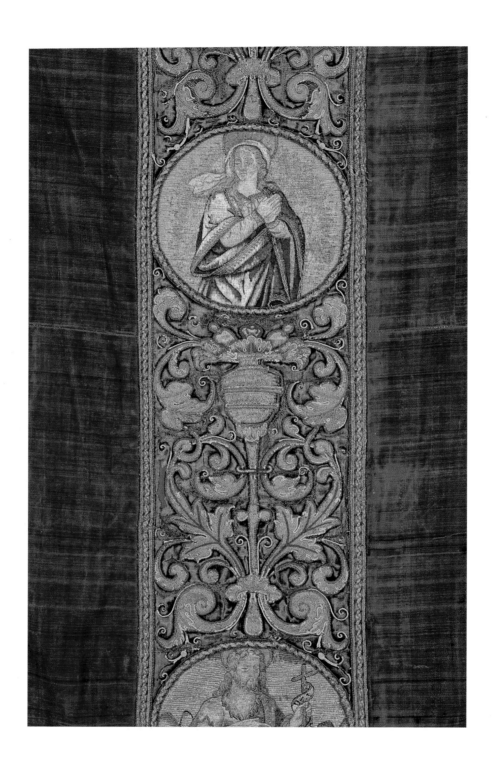

PLATE 2
Italian
Chasuble with Orphrey Band (detail),
late 16th–early 17th century
(Cat. no. 18)

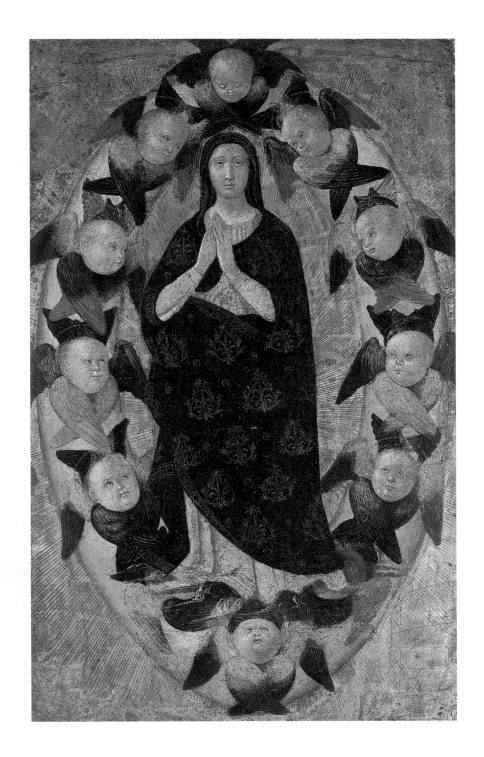

PLATE 3

Bernardino Fungai

Madonna in a Mandorla
Surrounded by Angels,
circa 1480–1516
(Cat. no. 21)

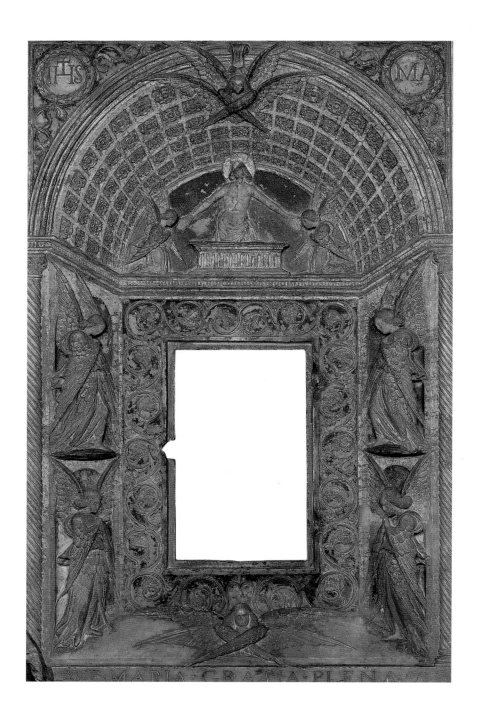

PLATE 4
Italian (Genoa)
Tabernacle,
mid-15th century
(Cat. no. 20)

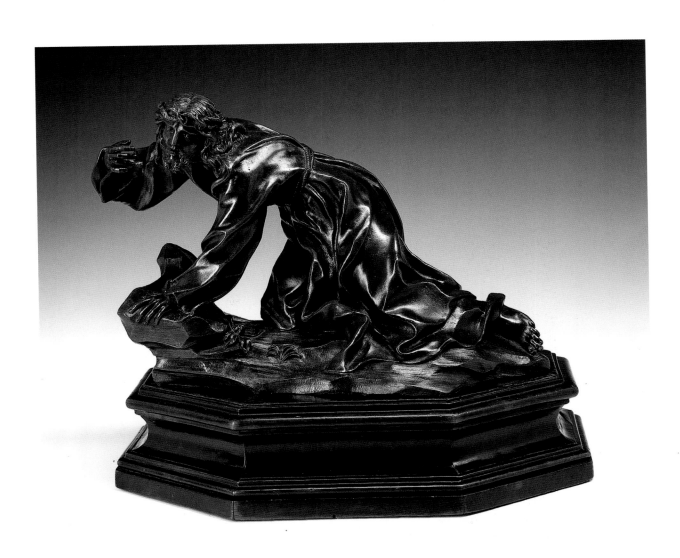

PLATE 5
Alessandro Algardi
Christ Falling beneath the Cross,
circa 1650
(Cat. no. 27)

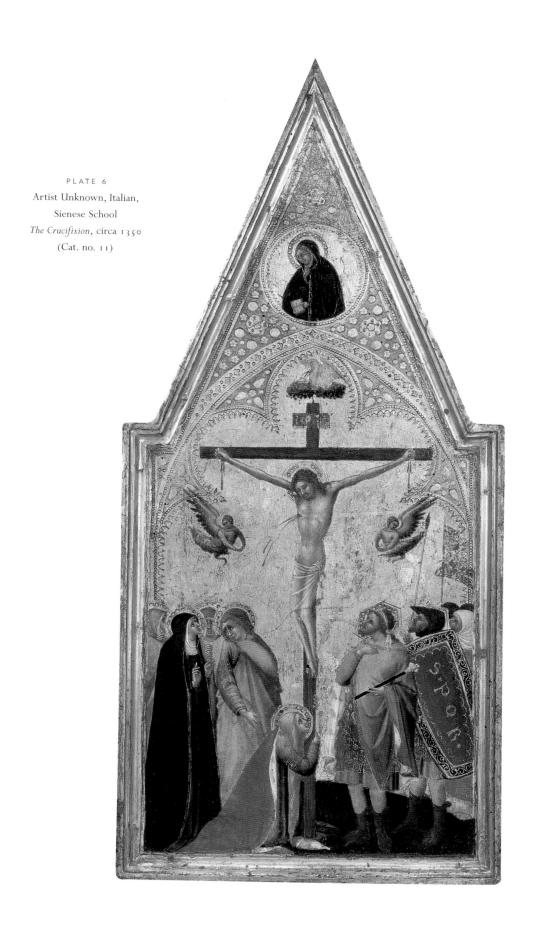

PLATE 6

Artist Unknown, Italian,
Sienese School
The Crucifixion, circa 1350
(Cat. no. 11)

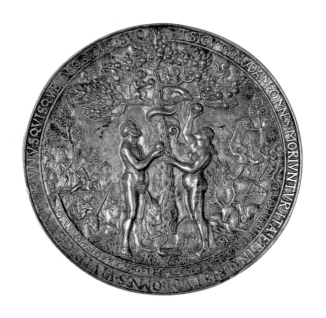

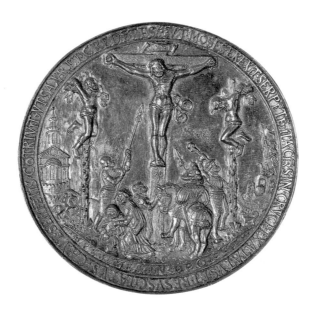

PLATE 7

Hans Reinhart the Elder

Medallion: The Fall of Man (obverse),

The Crucifixion (reverse), 1536

(Cat. no. 7)

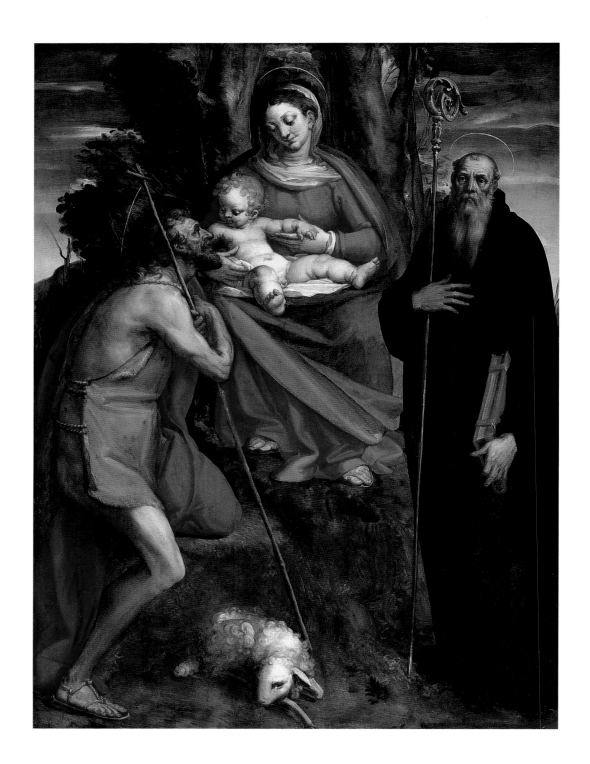

PLATE 8

Luca Cambiaso

Madonna and Child with Saint John the

Baptist and Saint Benedict,

1562

(Cat. no. 29)

PIOUS JOURNEYS

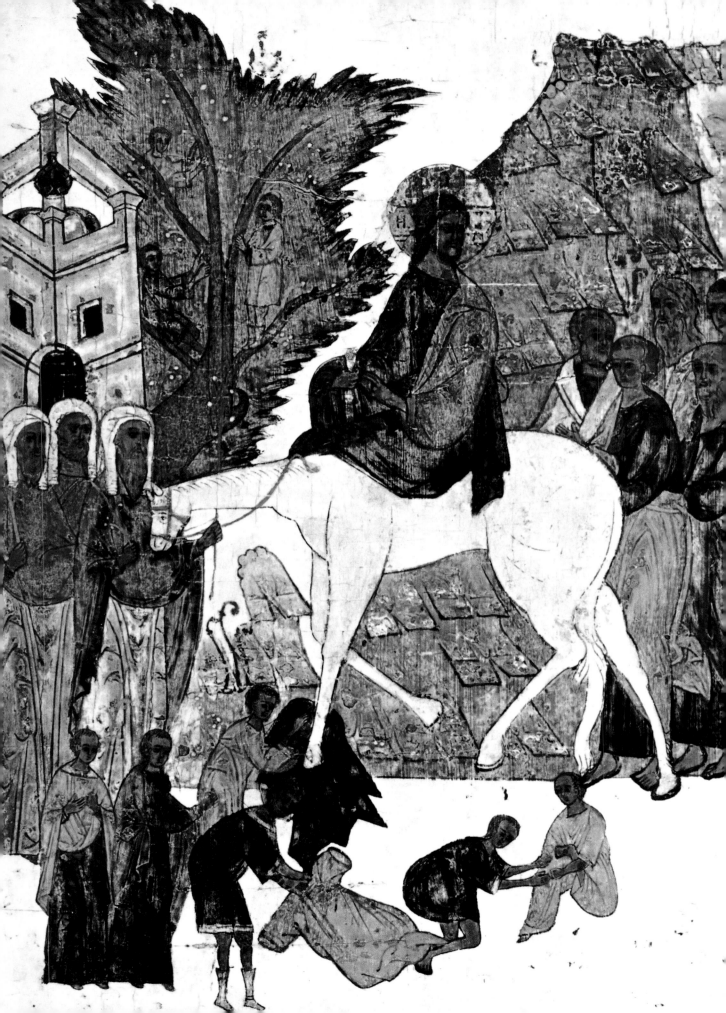

In medias res
Objects and the Mobilization of Collective Piety

he title of this exhibition, *Pious Journeys*, deliberately references actions more than it does objects and images whose precious materials and crafted forms lay claim to our attention in the museum. For, in fundamental ways, our habits of viewing differ from those of the people who would have beheld such objects in the later Middle Ages. Whereas we are constrained to admire from afar the carved details on the folding ivory diptych from late fourteenth-century Paris as it stands within its plexiglass case (FIG. 1), viewing of the narrative scenes carved on the panel's inner surfaces was originally an event in which physical manipulation of the dimunitive panels played a meaningful part. Hinges remind us of the diptych's book-like structure,

MATTHEW SHOAF

3

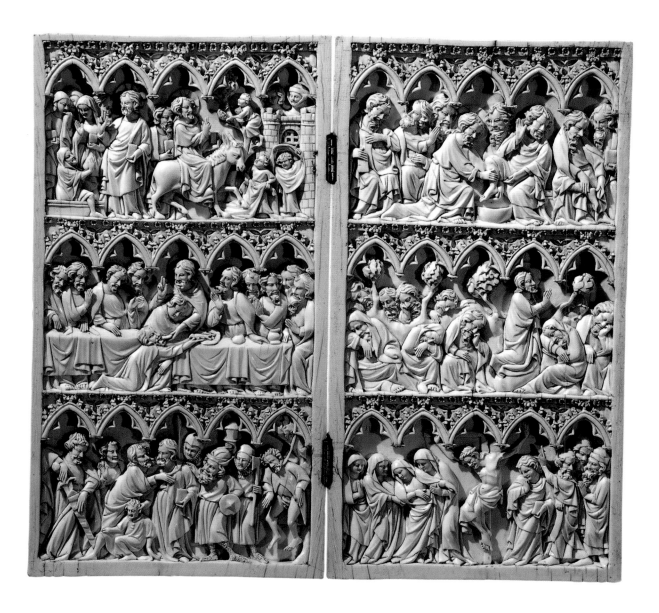

FIG. 1

French (Paris), *Diptych with
Scenes of the Passion of Christ*,
circa 1370–1380
(Cat. no. 22)

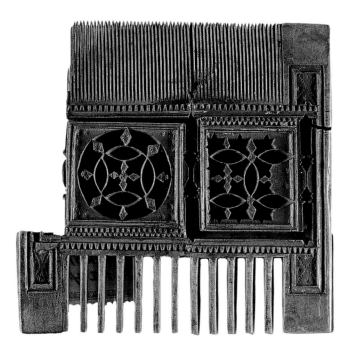

FIG. 2
French, *Liturgical Comb*,
late 15th century
(Cat. no. 19)

and intricacies of carving summon the viewer to linger over details as one would over a manuscript.[1] The varied poses and gestures of the diptych's many figures force the viewer to "enter into its interior," in Harvey Stahl's words, to "accept its artifice, and become absorbed in its settings and events."[2]

The sequence of gestures that opened and closed the tiny panels occurred in accordance with a timetable that was imposed and maintained by the Church and that was organized into rounds of hourly, daily, weekly, and annual activities. Thus, we need to recognize that the experiences such an object mobilized for its viewer positioned individual action within the larger temporal unit of Christian narrative as it was celebrated in the Church calendar, and we must think of looking as a regulated activity, limited but repeatable, personal as well as collective, with its explicit connotations of dutiful conduct.

The basis of the regularization of the Church calendar, according to R. N. Swanson, was liturgy.[3] By "liturgy" scholars mean devotional acts of personal as well as collective behavior that follow a prescribed form. The priest's reenactment of Christ's sacrifice in the Mass was the central practice of the liturgy; other patterned ritual celebrations, some of which allowed for private practices, remembered key events in the lives of Mary and Jesus as well as the feast days of saints.

Objects had diverse roles in liturgical observance, beginning with the ritual preparation of its participants for liturgical performance. Liturgical combs like the Smart Museum's late fifteenth-century example (FIG. 2) were used in the priest's preparation for the performance of the Mass and possibly also in the anointing of bishops. Such combs were integral to liturgy as early as the Carolingian period (eighth to ninth centuries). William Durandus, whose late thirteenth-century writings on church ceremony became authoritative, held liturgical combing to be important for the order and cleanliness of the mind.[4] The

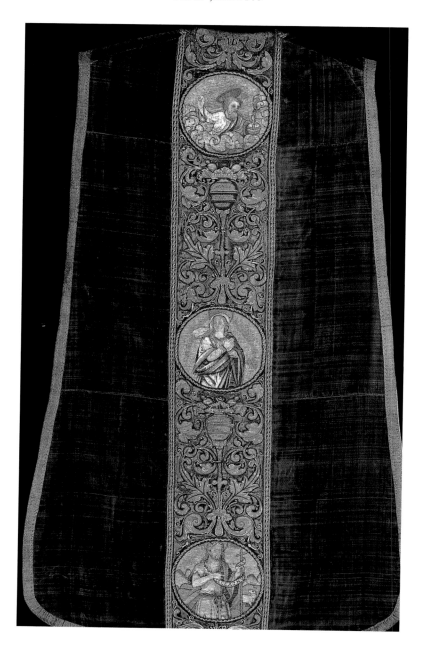

FIG. 3
Italian, *Chasuble
with Orphrey Band*,
late 16th–early
17th century
(Cat. no. 18)

comb could remind Church officials and their attendants that pious action required an appropriate mental state. To this end, a prayer to God recited during the combing would impart a spiritually salubrious purpose to the action: "Inside and outside my head and whole body and my mind, O Lord, your nourishing spirit purifies and cleanses."[5]

Another central element of priestly preparation was the donning of special vestments, such as the Italian chasuble with orphrey band from the late sixteenth or early seventeenth century shown in this exhibition (FIG. 3/COLOR PLATE 2). For centuries, bishops and priests wore this type of garment while celebrating Mass. The orphrey, or decorative band, would have overlaid the chasuble in a distinctive compound scheme. These vestments marked the cleric as a conductor of liturgy and set an appropriately formal tenor for ceremonial participants and observers. Thus, both liturgical vestments and combs served transformational

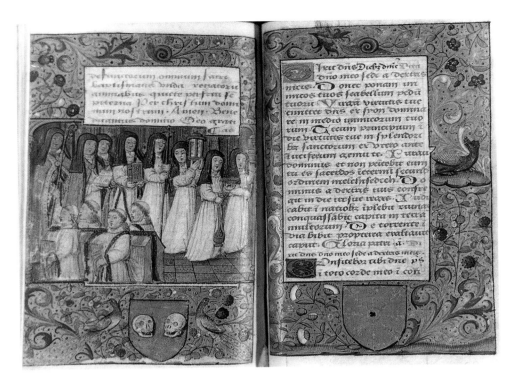

FIG. 4
French (Tours?), *Book of
Hours of Louis XI*:
Monastic Procession,
circa 1480
(Cat. no. 43)

functions. They distinguished liturgy's leaders, announced its solemn commencement, and called for an appropriate frame of mind among those present.

In addition to their utility in initiating liturgical events, objects also contributed to liturgy's elaboration in time and space. Some helped to define a stationary destination or locus of liturgical action, such as an altar (the focal point of the Mass), while others shaped collective movement—and, by extension, collective piety—between such places. Processions were conducted under a variety of circumstances, sometimes in accordance with calendrical feasts and sometimes in response to unforeseen events such as disaster and death. Objects were integral elements in organizing both the processors who bore them and the procession itself.

An illumination accompanying a prayer for the dead in the *Book of Hours of Louis XI* (FIG. 4) gives some idea of how processions and processional objects functioned. Here we witness a funerary procession featuring a draped coffin borne by four monks. A line of female religious lead the monks, each woman carrying a different object: a crozier, an open book, a closed book, a processional cross, a reliquary or monstrance, a censer and bowl, and a chalice. The order in which the objects appear reinforces the institutional rank of the figures bearing them, with the highest ranking women, notable also for their more elaborate vestments, taking their places at the rear. Together, the objects, vestments, and spatial dispositions give visual definition to a collective action; persons and things appear as components of a greater endeavor. Thus, liturgy transfigures not only time and space during the course of its performance; it also transforms the identity of its participants, reordering their relation to others in collective terms.

In Christian practice of the Middle Ages and beyond, the "ultimate frame of reference" that attended liturgy was, according to Ronald L. Grimes, the narrative of humanity's fall from paradise, with the possibility of redemption at the end of history.[6] As the Fall was said to have occurred near the beginning of time (Gen. 3) and Redemption was to take place

at some point in the future, Christians perceived themselves as living in an intermediate period. The objects they used in their observances also stood *in medias res*; they marked the middle of a journey by relating present human to activity to the overarching story of God's creation.

The elision I have made between "journey" and "story" is purposeful, for it helps us to think about the relation of piety to the objects discussed in this essay. The etymological root of "journey" is *jour*, the French word for "day," a measure of time. Movement is a defining trait of journeys. At the same time, journeys are themselves comprised of units, such as a beginning, middle, and end. This structural quality suggests that the journey is a unit of experience that has what we may call a "narrative disposition." That is, a journey is similar in form to a story and bears features marking it as such, so that participants know when they are at a beginning or an end point, or when they are moving between the two. "Participant" may not even be the best term to use for those undertaking a journey; the word "protagonist" might be more appropriate. In a sense, to be a Christian is to be a protagonist in a common journey, which observances such as the liturgy could bring to mind.

One function of the ivory diptych (FIG. 1) was to trace such a journey. Indeed, its figures and their visual organization into six rectangular enclosures blur the distinction between journey and story. Here a series of episodes selected from the more extensive accounts of Jesus' Passion found in the Gospels, begins literally as a journey, with Jesus riding atop an ass. The frequent repetition of the figure of Jesus makes him the ivory's chief protagonist, and the represented scenes trace both his progress and that of his story: Christ's Entry into Jerusalem at the upper left is the story's introduction, and its conclusion occurs on Golgotha, the site of the Crucifixion.[7] The literal movement of Jesus from place to place is the movement of the story itself. Since the depicted episodes correspond to events that were commemorated by the Church during the week between Palm and Easter Sundays, Easter week may have been the occasion during which the diptych was handled and opened.

Mutual identification between protagonist and story was particularly important in late medieval devotional practice, which in various ways endeavored to imitate the actions of Christ. In following Jesus' human itinerary from one event to another, the faithful simultaneously undertook the same journey, enacting his story in order to feel nearer to him and, by extension, closer to salvation after death. The ivory diptych not only traces this itinerary, but also animates it by enabling viewers to become protagonists of a Christian journey-by-proxy.

From the point of view of the Church, it was not the individual's place to decide when, where, and how spiritual journeys were to be conducted. Individual choice could too easily lead one to stray from what the Church recognized as legitimate. The vigor with which the Church pursued and persecuted nonconformists (who were labeled "heretics," among other things) during the Middle Ages and well beyond is notorious. Less examined, though perhaps born of similar impulses, were the ubiquitous, often tacit injunctions to acknowledge authority and subordinate oneself to it; to do otherwise, according to thirteenth-century bishop William Durandus, was "to wander beyond the limits of right reason."[8] In other words, disregard for authority was conceived of as aimless (damnable) movement, lacking the ultimate destination, eternal salvation.

Images and objects had a major role in affirming and publicizing the compliance required by the Church of its clerics and lay attendants. Images of historical figures played an important role in such promotions. A Veneto-Byzantine panel painting of Saint Jerome (FIG. 5), for example, depicts the fourth-century priest who was recognized in later centuries, along with Ambrose, Augustine of Hippo, and Gregory the Great, as one of the Latin Fathers of the Church. Though Jerome was most famous for translating the Bible into Latin (the Vulgate), pictures of him could draw out other stories and associations. This image

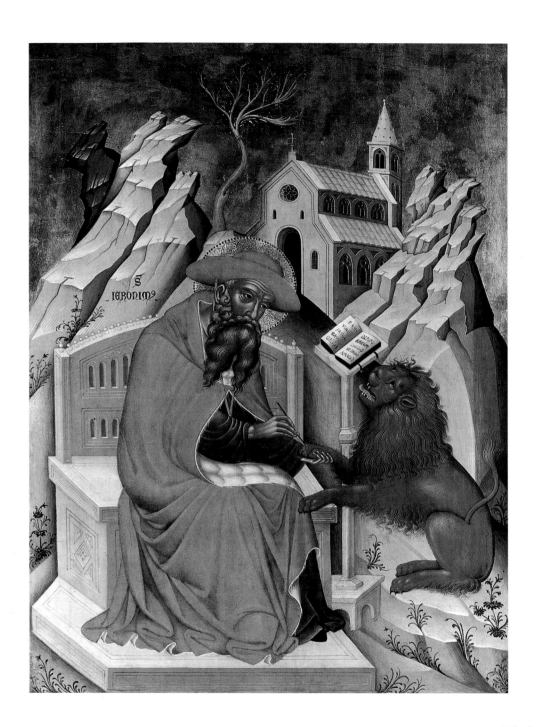

FIG. 5

Veneto-Byzantine School,

Saint Jerome, 16th century

(Cat. no. 16)

reminds us of a well known episode in which Jerome removed a thorn that was embedded in a lion's paw. The good deed earned the lion's gratitude, and the beast became the saint's companion and servant.

In addition to emphasizing the peaceful interchange of the two figures, the artist embellished this tale with the trappings of authority. Jerome's great throne, cardinal's hat, and robe call attention to his elevated position within the Church. The solid edifice in the background, hemmed in by savage rocks, reinforces this status. Equally suggestive of the saint's authority is the nearly central position of an open book on a lectern, identifying Jerome as an assiduous reader of the Bible and an authority on the written word.

Church officials used the wordless language of objects to acknowledge and promote scripture as the source of divine truth. Books, lavishly bound in precious materials and prominently displayed, were transformed into something beyond devices for reading. We have already seen that books were carried in processions where, in one example (FIG. 4), they are held by the high ranking figures to the rear. In the course of other liturgical services, the Gospel might have been carried by a deacon down the center aisle of a church, taken into the sanctuary, and placed on the altar along with the primary implements for conducting the Mass.[9] An image of Saint Gregory saying Mass, from a French Book of Hours of around 1490 (FIG. 40), shows the privileged position typically enjoyed by the book. An open volume, carefully posed on a cushion, is depicted in its familiar position on the altar, and here at the scene of a legendary turn in the most important of liturgical events, the Eucharist.[10] The miraculous vision of Gregory—depicted in the manuscript as the dying Christ bleeding into the ceremonial chalice—was taken as proof that the act of transubstantiation performed during the Mass was not just symbol but an actual miracle: wine and bread were literally transformed into blood and flesh (see Rosenstein, pp. 33–34).

In their outward appearance as well as in their contents, books promoted reverence for Jesus—the word of God made flesh—and those who propagated his teachings. For example, an Armenian book cover made of silver repoussé features a concentric arrangement of figures that conveys the idea of a radial network of absolute authority (FIG. 6). The crucified Christ, the most common image on Armenian silver bindings, occupies the center.[11] His open eyes suggest that he has triumphed over death. Two bearded holy figures, perhaps locally venerated saints, flank him. These three figures occupy a special area defined by an oval of medallions depicting the twelve apostles, Jesus' original followers. Four larger medallions in the corners contain images of Matthew, Mark, Luke, and John, the officially recognized biographers of Jesus and authors of the Gospels.

All these figures are nimbed—they wear haloes, denoting holiness—and all face the viewer. As a whole, this composition orients its audience toward a hierarchy of authority: one could not look at the book, or grasp its edges, without being positioned with respect to a Christocentric world of meaning and recalling one's own place as a recipient of these transmitted truths. A remarkable aspect of this cover is that it diagrams the centrality of its contents in the practices and beliefs of the Church. Its figured surface "authorized" the pious manner of the book's treatment and display during liturgy.

Objects such as this one endowed liturgical actions with meaning and a sense of purpose not necessarily implied in the actions themselves. In order to do this, they had to be easily integrated into liturgy (ideally, they were portable) while also standing out as immutable and enduring (through richness of materials and craftsmanship). The Martin D'Arcy Museum's processional cross from northern Italy (FIG. 7), for example, was designed for maximum visibility as it was carried through the crowded spaces of church and city. Mounted on a long staff, its gilt copper and silver form shimmers in the presence of light. The artist modulated flat surfaces in order to enhance the appearance of preciousness. The figure of Christ is distinguished by its rendering in high relief, its specific metallic composi-

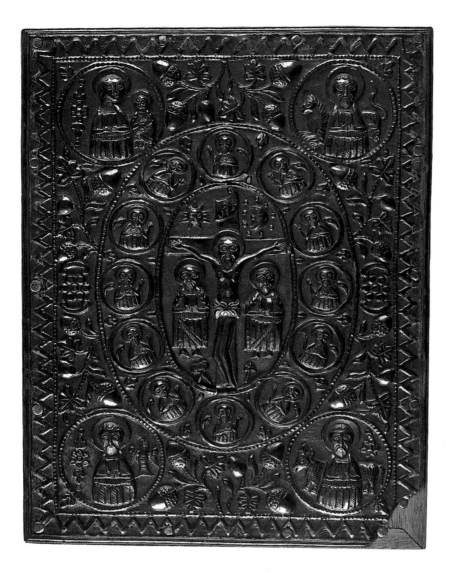

FIG. 6
Armenian,
Book Cover: Crucifixion,
1700–1750
(Cat. no. 15)

tion (cast silver, partly gilded), and its central position between the lamenting figures of Mary and John the Evangelist which are rendered in low relief. The emphasis on Christ's body, pierced by oversized spikes, reminded the faithful of his suffering and self-sacrifice.

It is interesting to note the position of the cross among the objects represented in the illumination from the *Book of Hours of Louis XI* (FIG. 4): it is carried by the fourth figure from the right, before a closed book—probably a Bible—and behind a reliquary or monstrance, conferring to it a transitional status between the written word and the liturgical objects designed to focus on Christ's bodily sacrifice. In this position the cross is important not as a singular image but as part of a series of objects to be handled and venerated as varying, nuanced manifestations of a unified sacred authority.

While portability was paramount to the uses of such objects, other artworks were stationary and drew pious worshipers toward them by means of compositional devices. Perhaps the most basic of these is frontal orientation, a feature of Western artistic traditions that is so common as to seem almost natural and that often goes unremarked. Yet its impli-

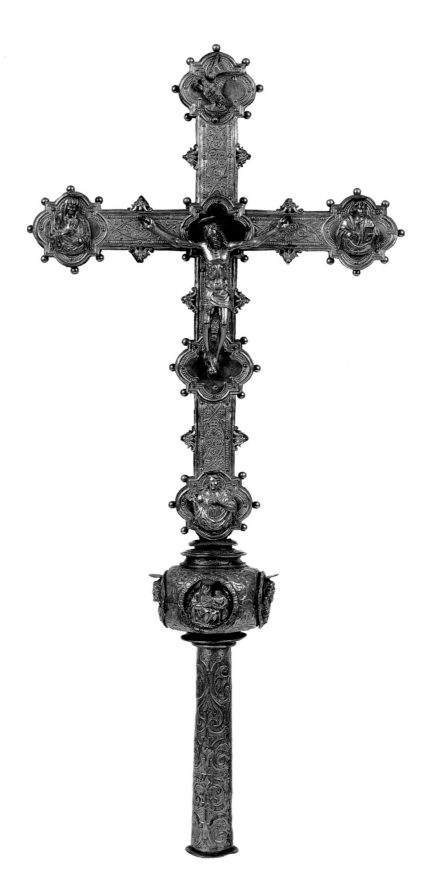

FIG. 7
North Italian,
Processional Cross,
15th–16th century
(Cat. no. 17)

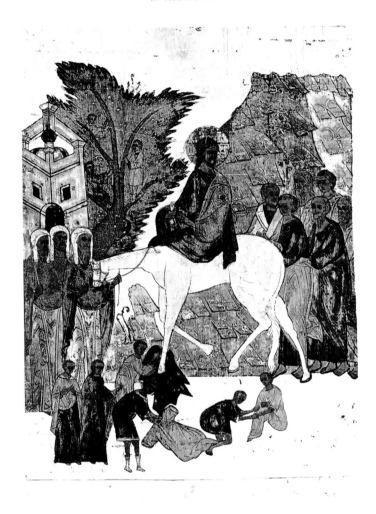

FIG. 8
Artist Unknown, Russian,
Novgorod School, *Triumphal
Entry of Christ*, 16th century
(Cat. no. 23)

cations with respect to behavior are considerable because it demands an arrest of movement and a focus of attention and action on the part of viewers. A Russian panel displaying Christ's Entry into Jerusalem exemplifies this formal strategy (FIG. 8). This image transforms an episode from the Passion—one which we may recall from the narrative sequence of the ivory diptych—into an icon, giving it independence and distinction from other facets of Jesus' story. This panel was probably once attached to an iconostasis, a "wall of pictures" that separated the altar space from the rest of the church in late fourteenth-century Russian ecclesiastical decoration.[12] Other icons featuring locally important feasts or saints may have flanked it, but they would not have related to it thematically or as part of a narrative continuum. Here, groups of standing figures enclose the mounted Jesus and direct attention to him. He appears in transit, framed by the mountains and the city gate that are a cue to his act of journeying and that offset the venerated moment of his arrival.

Frontal and stationary works were made to stage an interaction with viewers, commanding their undivided attention. Medieval sources tell us that such encounters were intended to provoke the memory and focus the energies of churchgoers. Thirteenth-century Genoese bishop Jacobus de Voragine wrote that images of the Crucifixion should stimulate recollection of the Passion of Christ, arouse devotion to it, and instruct in a way "directed to the eye."[13] His contemporary William Durandus promoted the use of images more generally and explained their particular utility as compared to texts:

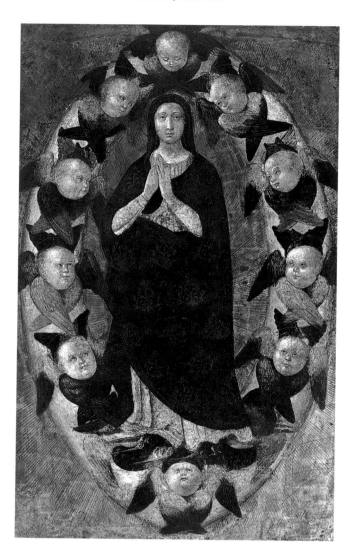

FIG. 9
Bernardino Fungai,
Madonna in a Mandorla
Surrounded by Angels,
circa 1480–1516
(Cat. no. 21)

Paintings appear to move the mind more than descriptions; for deeds are placed before the eyes in paintings, and so appear to be actually carrying on. But in description, the deed is done as it were by hearsay: which affecteth the mind less when recalled to memory. Hence, also, it is that in churches we pay less reverence to books than to images and pictures.[14]

Here Durandus spoke of painting's special capacity to attain a goal it shares with text: to "move the mind." The distinguishing attraction of paintings, he explained, is the presentness they give to events of the past, thus furthering the overall goals of liturgy.

Fixed, stationary images heightened the intensity of encounter between viewers and holy figures in church settings. Sienese artist Bernardino Fungai, painting in the late fifteenth and early sixteenth centuries, enclosed his Madonna in the honorific form of the mandorla in a depiction of her exceptional bodily assumption into heaven (FIG. 9/COLOR PLATE 3). Though this event attained the official status of dogma only in 1950, it was widely commemorated on a liturgical feast day (August 15) with late sixth-century origins.[15] The mother of Jesus stands in the center of this panel and faces out from a celestial realm. Following the development of her cult in twelfth-century Europe, part of Mary's importance to Christians lay in her status as a patron and divine intercessor on the behalf of individuals, groups, and entire cities, particularly in Italy. Her piety, emphasized here by a gesture of prayer, invited similar acts of devotion from viewers.

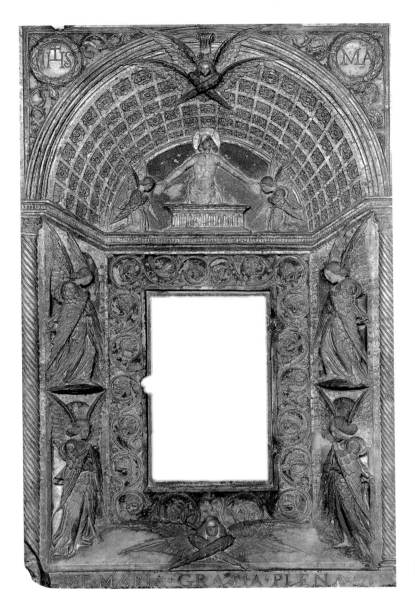

FIG. 10
Italian (Genoa),
Tabernacle, mid-15th century
(Cat. no. 20)

While Fungai's painting provides a model of devotion and an affirmation of Mary's exceptional status, it also offers an occasion for what Hans Belting has called a "dialogue" between viewer and cult figure.[16] Such an exchange might include the utterance of a personal prayer or a prescribed monologue. Inscribed at the bottom of a mid-fifteenth-century tabernacle frame (FIG. 10/COLOR PLATE 4), which would have been affixed to a church or chapel wall, is a direct, verbal prompt for an appeal to the Madonna: AVE MARIA GRATIA PLENA ("Hail Mary Full of Grace"). While the tabernacle now lacks what we can assume from this inscription to have been an image of Mary, it still demonstrates the elaborate measures taken to assure a singular and exalted exchange, via the object, between intercessor and viewer. Through the use of converging diagonal lines, the artist created the illusionistic space of a chapel; a chorus of angels turns toward this space and the image it once contained with deference. Directly above, the body of Christ rises from the tomb, attended by more angels. Mary's image would thus have been linked to that of her resurrected son, making explicit her role as mediator between the worshiper and the divine.

Donato Creti's much later oil painting *Saint John the Baptist Preaching* (FIG. 11/COLOR PLATE 1) establishes a different kind of rapport between viewer and painted figure. John the Baptist, whom the Gospels relate as a contemporary and an advocate of Jesus, here harangues a crowd gathering in a remote wilderness setting. The scene may call to mind the account from the Gospels in which John stands at the bank of the Jordan River and urges his listeners to repent their sins. He also alerts them to the imminent arrival of Jesus, their divinely appointed savior. Yet the painting is no mere "illustration" of the text. Creti has taken measures to make us feel a part of the crowd attending the Baptist's proclamations. For example, he created a space between foreground and middle ground where he could depict movement toward the Baptist from the viewer's direction. Figures arrive by boat on the right, while on the left a man clambers up a bare rock to reach the Baptist. The viewer is invited to follow these figures in anticipation of a similar encounter. A young woman peering out from the left side of the picture meets our gaze, increasing our sense of being present at this event.

Up to this point, I have focused on objects bearing figural imagery, but non-figural objects also had a role to play in mobilizing and organizing piety. Books (other than the Bible, and often unillustrated) were necessary material means for coordinating performances basic to liturgy and for furnishing them with content. Important books for the Mass included the sacramentary, lectionary, festal mass book, ordo misse, kyriale, gradual, cantatorium, sequentiary, and missal. Books for the Divine Office furnished daily rounds of readings, prayers, and/or songs. Office books included the collectar, lectionary, ordo, psalter, ferial or choir psalter, antiphonary, benedictional, and breviary. From the sheer complexity of this list we gather a sense of the wealth of textual materials directed at liturgical practices—an abundance that presupposes institutional mastery of their handling and coordination.

The impressively large antiphonary from Basel, now in the collection of the Newberry Library, is the first printed antiphonary, a fifteenth-century book that furnished music for daily and nightly prayers and praises for the Divine Office (Cat. no. 13). Antiphonaries vary in content, though their music typically met the liturgical needs of different parts of the year. As the name suggests, antiphonaries were used for responsive singing. In antiphonal psalmody (the singing of psalms), several choirs alternated and united voices.[18] Choral singing drew individual voices into a larger effort, much as processions transformed individual movements into a collective act of piety. The massive size of the Basel antiphonary, and its prominent staves and stark black musical notation, were intended to be visible to choral participants so that together they could follow its directions in ordered unity.

Drawing a sharp distinction between figural and non-figural objects may obscure otherwise suggestive similarities in how they could shape piety. The antiphonary, for example, shares with the ivory diptych a structuring of visual experience intended to guide the mind and move the spirit. Its lines and notes direct the eye to move across the page with a repetitive and carefully placed order. Similarly, the diptych transforms Jesus' journey into an activity of measured repetition: within a regularized, ordered frame of arches and rectangles, diverse figural compositions are given a nearly rhythmic structure. These framing elements propose a codified, measured mode of viewing akin to that structuring a page of music.

The relation of objects to pious behavior could be complex and manifold. Issues of piety—its time and place, its relation to the overarching frame of Christian history, its honoring of authority figures, and the material structures underpinning its practice—suggest that liturgical objects cannot be defined with baldly utilitarian or iconographic explanations. We may know little about the personal identities of those who used and made these objects, but we can surmise that a significant dimension of their piety involved an active identification with collective performance, thought, and purpose. One of the challenges posed by the objects featured in this exhibition is to reconstruct how each, in its own way, may have contributed to the individual's pursuit of salvation within a community of worshipers.

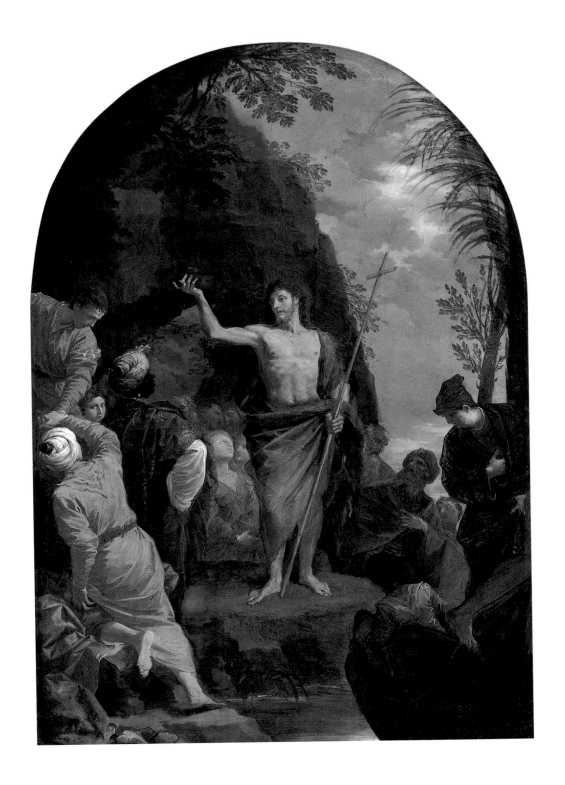

FIG. 11

Donato Creti, *Saint John the Baptist Preaching*, circa 1690–1710

(Cat. no. 12)

NOTES

1. Harvey Stahl suggests this analogy; see Stahl, "Narrative Structure and Content in Some Gothic Ivories of the Life of Christ," in *Images in Ivory: Precious Objects of the Gothic Age,* ed. Peter Barnet (Detroit: Detroit Institute of Arts, and Princeton, N.J.: Princeton University Press, 1997), 95.

2. Stahl, 96, describes this aspect well in his discussion of the viewing of a small ivory: ". . . one must enter into its interior, accept its artifice, and become absorbed in its settings and events."

3. R. N. Swanson, *Religion and Devotion in Europe, c. 1215–c. 1515* (Cambridge: Cambridge University Press, 1995), 92ff. Swanson indicates that Roman Catholic liturgy became markedly standardized in the fifteenth century, but he also stresses the occurrence of localisms.

4. *The Medieval Treasury: The Art of the Middle Ages in the Victoria and Albert Museum,* ed. Paul Williams (London: The Victoria and Albert Museum, 1986), 72. See also Margaret English Frazer's discussion of combs as secondary liturgical objects in "Medieval Church Treasuries," *The Metropolitan Museum of Art Bulletin* 43, no. 3 (winter 1985/86), 20–37.

5. *Dictionnaire d'archéologie chrétienne et de liturgie,* vol. 13, no. 2 (Paris: Librairie Letouzey et Ané, 1938), coll. 2934-35.

6. Ronald L. Grimes, *Beginnings in Ritual Studies* (New York and London: University Press of America, 1982), 43; Theodore W. Jennings, Jr., "Liturgy," in *The Encyclopedia of Religion,* ed. Mircea Eliade et al., vol. 8 (New York: Macmillan, 1987), 580–83.

7. The reader will observe that the Entry into Jerusalem shares its cartouche with a representation of the Raising of Lazarus of Bethany from the dead, positioned off-center to the left. In the Gospel of John the Raising of Lazarus occurs a few days before Jesus enters Jerusalem and thus precedes the Passion proper. A couple of points may help us to consider the function of the Lazarus episode among the diptych's imagery. First, it comes before the Entry into Jerusalem but yields to the latter a majority of the cartouche space. To use modern textual parlance, it is "prefatory" rather than "introductory." Second, its inclusion allows for an understanding of Jesus as a miracle worker, a circumstance not alluded to elsewhere in the imagery but one that suggests a motive for his eventual capture and execution, seen in the diptych's bottom cartouches. The nature of the miracle itself—resurrection of the dead—may arguably have informed the meaning of his crucifixion. Here a man who can bring the dead back to life does not resurrect himself. From this perspective, the "prefatory" Raising of Lazarus would appear to amplify a sense of self-sacrifice at the story's "conclusion" in a way that the Passion scenes themselves could not. Self-sacrifice was a principal theme in late medieval devotional material, especially with regard to the Passion, and was the central event commemorated through the Mass.

8. William Durandus, *The Symbolism of Churches and Church Ornaments: A Translation of the First Book of the* Rationale Divinorum Officiorum, *Written by William Durandus, Sometime Bishop of Mende,* trans. John Mason Neale and Benjamin Webb (New York: Scribner's, 1893), 53.

9. Susan A. Boyd, "Art in the Service of Liturgy: Byzantine Silver Plate," in *Heaven on Earth: Art and the Church in Byzantium,* ed. Linda Safran (University Park, Penn.: Pennsylvania State University Press, 1998), 165.

10. According to popular legend, Christ's presence at Gregory's elevation of the Host (the climax of the Mass) became literalized in flesh in order to convince an onlooking unbeliever that a piece of bread could become Christ himself.

11. Dickran Kourymjian, "Armenia, VI: Other Arts," in *The Dictionary of Art,* ed. Jane Turner, vol. 2 (New York: Grove Dictionaries, 1996), 442.

12. See George Heard Hamilton, *The Art and Architecture of Russia* (Middlesex and Baltimore: Penguin Books, 1954), 66.

13. Jacobus de Voragine, *The Golden Legend: Readings on the Saints*, trans. William Granger Ryan, vol. 2 (Princeton, N. J.: Princeton University Press, 1993), 385.

14. Durandus, 45.

15. L. Rosano, "Maria," in *Enciclopedia dell'arte medievale*, vol. 8 (Rome: Istituto della Enciclopedia Italiana, 1997), 205. According to the *Golden Legend*, the proper date of the feast's celebration rests on Jerome's authority; Voragine, vol. 2, 83. Voragine, in fact, cited Jerome in connection with the doubts of the Church regarding the details of Mary's bodily assumption into Heaven. In general, however, the Church defended the fact of the event, as Voragine implied. With the details about the Assumption in question from the Church's perspective, it may strike us that artists were untroubled in their vivid renderings of the event. Anna Jameson observed that "as the Church had never settled in what manner she was translated into heaven, only pronouncing it heresy to doubt the fact itself, the field was in great measure left open to artists"; see *Legends of the Madonna as Represented in the Fine Arts* (London: Longmans, Green, and Co., 1891), 318.

16. Hans Belting, *Likeness and Presence: A History of the Image before the Era of Art*, trans. Edmund Jephcott (Chicago: University of Chicago Press, 1994), xxi ff. Belting, xxi, explains this humanization of the image: "The image, understood in this manner, not only represented a person but was also treated like a person, being worshiped, despised, or carried from place to place in ritual processions." Belting's allusion to the spiteful treatment of images is noteworthy, as it calls to our attention that pious behavior toward images was by no means a given.

17. Andrew Hughes, *Medieval Manuscripts for Mass and Office: A Guide to Their Organization and Terminology* (Toronto and Buffalo: University of Toronto Press, 1982), 160.

Bodies of Heaven and Earth
CHRIST AND THE SAINTS IN MEDIEVAL ART AND DEVOTION

Those who behold [relics] embrace, as it were, the living body in full
flower: they bring eye, mouth, ear, all the senses into play, and then,
shedding tears of reverence and passion, they address to the martyr
their prayers of intercession as though he were present.

—SAINT GREGORY OF NYSSA, CIRCA 335–394[1]

he fragmented bodies of Christian saints were received in the Middle Ages by the faithful as "intimate friends."[2] Because the spirit of a saint was present in his or her bodily remains, these relics provided Christians still caught in the mundane realm with access to the divine. Beginning as early as the second century, pilgrims underwent physically arduous journeys to experience the protection and cures miraculously generated through the bodies of saints and martyrs, whose physical agony on earth made them especially powerful in healing the suffering of others. Indeed, the notion of the suffering

STEFANIA ROSENSTEIN

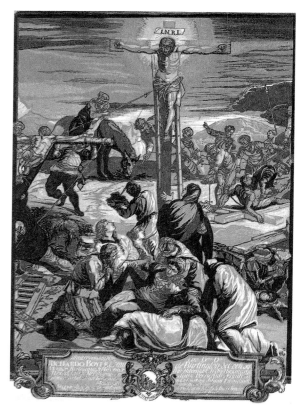

human body is central to Christian theology: God descended to earth incarnated in his son, Jesus Christ, specifically to bleed and die for the salvation of humanity (FIG. 12). Through the human (though simultaneously sacred) remains of the saints, medieval Christians reached the divine and were reminded of God's promise of bodily resurrection and eternal life in heaven.

In the centuries immediately after Christ's death, many of his followers died as witnesses to the Christian faith, imitating in various ways their savior's suffering on Calvary. Saint Stephen, who was stoned to death only a few years after Christ's crucifixion, was the first Christian martyr—or the "Protomartyr"—and as such he set an example of how to suffer for the Lord.[3] Late medieval and early modern artistic representations of these gruesome events, such as the Smart Museum's *Martyrdom of Saint Stephen* (FIG. 13), underline Stephen's bodily identification with Christ by portraying the martyr in poses evocative of Christ's Passion (FIG. 14/COLOR PLATE 5). As he is brutally tortured by his opponents, Stephen looks up to the cherubs who descend in order to adorn him with the crown of martyrdom and is simultaneously connected with both earth and heaven.[4] Similarly, saintly relics were understood as links between this world and the next, between the mundane and the miraculous. Stephen's cult, for example, developed in the early fifth century, when miracles were attributed to the newly discovered remains of his body.[5] Shortly thereafter, Augustine of Hippo confirmed the tremendous importance of these relics. In the final book of his *City of God*, Augustine credited the miraculous power of Stephen's body parts with prompting his own shift from opposition to the cult of relics to ardent proselytizing in its favor.[6]

Martyrs were not afraid of death; indeed, they welcomed it. They understood that it was only through the flesh—particularly in its suffering—that they could unite with a God whose body had bled for their sake.[7] In the late fourteenth century, Catherine Benincasa (later Saint Catherine of Siena) said, "Oh! How lovely it would be, were [my white robe]

FIG. 12

John Baptist Jackson

(after Jacopo Tintoretto),

The Crucifixion, 1740

(three panels)

(Cat. no. 50a)

stained with blood, for love of Jesus!"[8] According to a late medieval source, the fourth-century virgin martyr Saint Catherine of Alexandria (Catherine of Siena's namesake) (FIG. 15) similarly stated to her enemies, "Whatever torments you have in mind, don't waste time! My one desire is to offer my flesh and blood to Christ as he offered himself for me."[9] Accordingly, Emperor Maxentius prepared for her a horrible death in which she was to be torn to pieces by four large wheels, outfitted with saws and nails. When God answered her prayer to destroy the machine, thereby converting the assembled crowd to Christianity, she was sentenced to a beheading the next day. Francesco Fontebasso's painting *The Martyrdom of Saint Catherine* (FIG. 16) fuses the moment of the holy virgin's prayer with her subsequent decapitation: as she looks heavenward to the angels who celebrate her imminent martyrdom with great fanfare, the executioner prepares to raise his sword to her neck.[10]

Catherine's dying prayer—that her corpse not fall into pagan hands—reveals her understanding that the bodies of the most pious Christians were beneficial to the faithful crowds who beheld and touched them, and that these blessed individuals lived on in their relics. Patrick Geary, in his important study on *furta sacra* ("holy theft," or the theft of relics), notes that many Christian martyrs manifested concern for the destination of their bodies even after they met with earthly death. Through visionary revelations and other miraculous interventions, they exercised their will over their bodies, directing thieves and other devotees to the places where they wished to dwell.[11] According to legend, God responded to Catherine's final request by sending angels to transport her body to the revered site of Mount Sinai, where it still resides.[12] There, an oil (a balm, or "manna"[13]) miraculously "issues continuously from her bones and mends the limbs of those who are weak."[14]

Such sacred excretions were eagerly collected in souvenir ampullae by Christian pilgrims, who believed that the holiness infusing this liquid-relic was most effectively harnessed by physical contact.[15] Beginning in the fourth century, at the shrine of the martyred

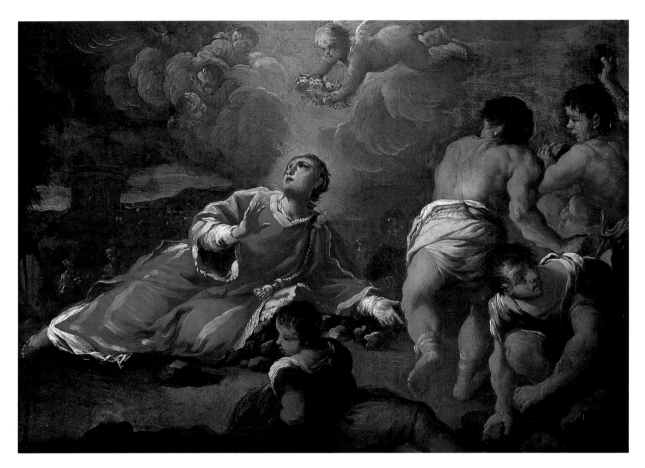

FIG. 13
Artist Unknown, Spanish (?),
The Martyrdom of Saint Stephen,
circa 1700–1750
(Cat. no. 26)

FIG. 14
Alessandro Algardi,
Christ Falling beneath the Cross,
circa 1650 (Cat. no. 27)

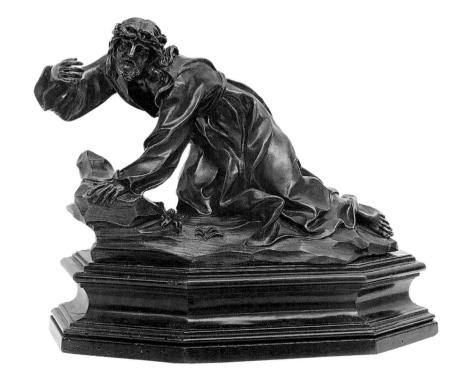

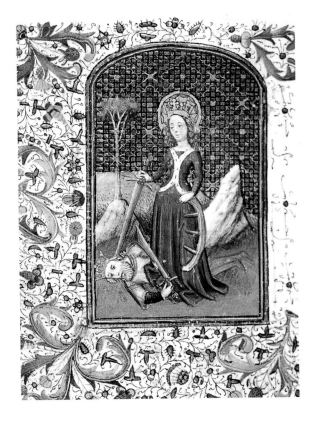

FIG. 15
Netherlandish, *Book of Hours,*
Use of Rome: Saint Catherine
of Alexandria, early 15th century
(Cat. no. 41)

FIG. 16
Francesco Fontebasso,
The Martyrdom of Saint Catherine, 1744
(Cat. no. 25)

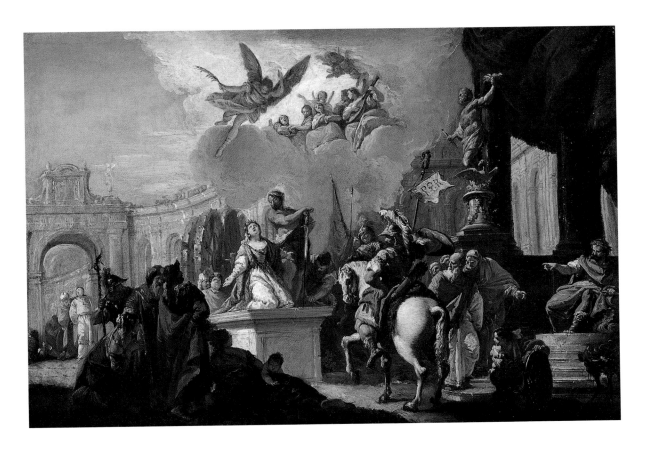

military hero Saint Menas the "Miracle Maker"[16] in Abu Mina (a pilgrimage site in the Libyan desert), faithful visitors could acquire mass-produced ampullae stamped with an iconic image of the saint (FIG. 17).[17] After enduring a difficult and dark journey to Menas's deep, underground crypt, these pilgrims filled the small bottles with healing oil from his tomb— an action described by contemporaries as the sealing of the saint's "kiss" to the devotee.[18] After the pilgrims left the sacred site, the benefits gained through their close encounter with Menas were perpetuated by these small oil-filled tokens (*eulogiae*, or "blessings"), which were kept close to the body as protection and intercessory aids in prayer.

The miracles and intercessions resulting from such intimate contact confirmed the *praesentia*, the saint's presence in his or her relics, which was of primary importance in devotional practices of the early and central Middle Ages.[19] Despite the essential centrality of the figure of Jesus in Christianity and the fact that saints were not to be worshiped, the early medieval faithful generally looked not to Jesus but to those martyred men and women who imitated him to provide the necessary link between God and humankind.[20] Martyrs' bodies were maimed both by those who wanted to destroy them (their enemies and executioners), as well as by those who revered them (participants in the cult of relics). To those who performed "pious mutilation" of the saints,[21] the fragmented body parts, with the saint wholly present in each, served as proof of perfect bodily resurrection to come on the Last Day.

Christian theology teaches that on that day, the bodies of the just will be reunited, glorified, and rendered incorruptible, and the saints' integrity in their scattered relics illustrated this doctrine for the faithful.[22] The precious metals and jewels that constituted the grand reliquaries of the Middle Ages demonstrate the medieval understanding that the saints' bodies reflect the glory received by their souls in the heavenly presence of God.[23] This is particularly true of "speaking reliquaries," those shaped to recall the very body part they were said to contain.[24] In the twelfth century, Peter the Venerable (the abbot of Cluny) praised the gift of a precious reliquary: "Today we celebrate on earth one whose merits are forever exalted in heaven. He shines now, according to the promise of the Savior, like a sun in the kingdom of the Father, he whose body this work of art contains."[25] To the faithful, the power of glorious effigies such as the *Reliquary Head of Saint Theobald* (FIG. 18),[26] which probably held the twelfth-century Italian saint's skull, lay precisely in the perception that body and soul were inextricably linked, and that the body could be an important means of accessing the divine.[27] Because the face is the most individualized and expressive part of the

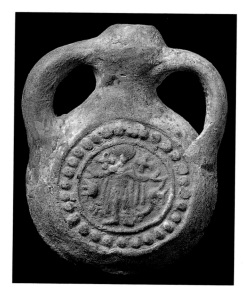

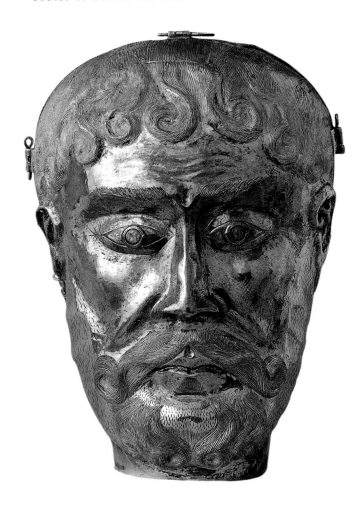

FIG. 18
Italian (Savoy),
Reliquary Head of Saint Theobald,
1300–1450 (Cat. no. 24)

body, reliquary heads were ideal in fostering intimate (human) communication between the saint and his or her devoted followers, even if the actual head was not contained within it. The penetration of Theobald's gaze and his mustached mouth, ready to open and speak, certainly made the saint's presence more immediate for those who encountered him through the reliquary. His tangible visage was proof of the physical presence of the saint on earth, and its splendor indicated divine reception. Through communication with this human intercessor (often realized by kissing the reliquary), the devotee's prayers were transferred to the divine realm and miraculously answered.[28] Indeed, it is recounted in legends that at Theobald's tomb, both after his death in 1150 and again upon the rediscovery of his relics in 1429, "many people dead are said to have been brought back to life by his sanctity."[29]

Reliquaries come in many forms. In addition to the type characterized by the *Head of Saint Theobald*, medieval communities honored relics with meticulously crafted, ornate containers that permitted viewing of the actual relic itself. The Smart Museum's elaborate *Farnese Reliquary* (FIG. 19), of several centuries later, exemplifies the sort of vessel that was elevated for viewing in the church (a practice that was common already in the twelfth century) and was carried in procession during feast days and the Corpus Christi celebration.[30] The églomisé (reverse painting on glass) on the covers of the central container of the Smart's reliquary is probably not original,[31] and it is likely that this object first functioned as an ostensorium, or a monstrance with a transparent window, probably rock-crystal, through

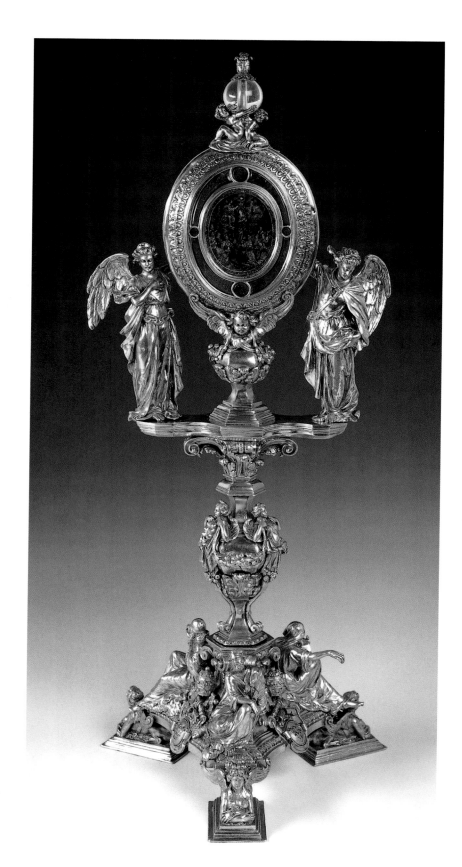

FIG. 19
Attributed to Antonio
Gentili da Faenza,
Farnese Reliquary, circa 1550
(with later additions)
(Cat. no. 28)

which the relic was visible.[32] The emergence of this sort of reliquary in the late Middle Ages and the practice of elevation associated with it attest to a growing emphasis on the power of sight, in addition to touch, as a vehicle for contact with the divine.[33] It also signifies that in the late Middle Ages, it was the saint's body itself and not its surrogate metallic skin that became the focus of display; the contents of the reliquary now had to be visible to confirm their power. In contrast to earlier "speaking reliquaries" like the *Head of Saint Theobald*, the Farnese piece, which was commissioned in the mid-sixteenth century by Pope Paul III or his grandson Alessandro Farnese, offers no formal clue to its original contents.[34] A similar example from about a half-century earlier, in the collection of The Metropolitan Museum of Art in New York, originally contained a tooth of Mary Magdalene.[35] Such reliquaries were also used for the presentation of the eucharistic Host.[36]

The dual role of this type of vessel—as both reliquary and monstrance—underscores the late medieval understanding of the consecrated wafer as a relic of Christ. Some medieval theologians, such as Guibert of Nogent, argued that the Eucharist was the only true bodily relic of Christ (who, because of the miracle of the Resurrection, left behind no physical remains). Others claimed that he did leave physical traces worthy of veneration: they declared both his foreskin, removed in his childhood at the Circumcision, and the Holy Blood to be legitimate and sacred relics.[37] Regardless of this controversy, a decree of the Fourth Lateran Council of 1215 confirmed that, at the moment of ritual consecration and elevation, the eucharistic elements of the bread and wine miraculously transubstantiated into the true body and blood of Jesus Christ. Just as the viewing of saintly relics in ostensoria was increasingly valued as an effective mode of communication with the divine in the late Middle Ages, gazing upon what was understood to be Christ's whole body, as Host in a monstrance, was considered to be as effective as actually consuming the Host: both led to a union with God and even mystic ecstasy.[38] The notions of "spiritual communion," "eating by sight," and "communion of the eyes" became so desirable (indeed, necessary for salvation)

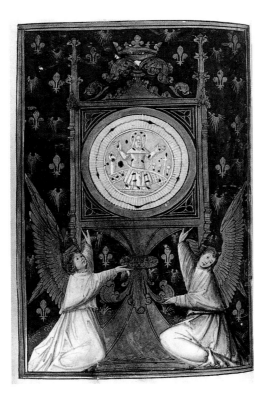

FIG. 20
Ogier Benigne's Book of Hours:
The Host of Dijon.
French, circa 1500.
The Walters Art Gallery, Baltimore
(not in exhibition)

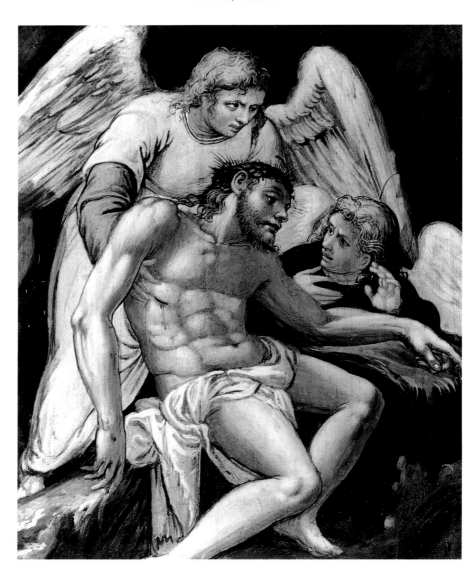

FIG. 21
Artist Unknown, Italian,
Deposition, late 16th century
(Cat. no. 32)

that the Host in a monstrance was sometimes shown in full-page illuminations in late medieval manuscripts.[39] Viewers of images like that of the Host of Dijon in *Ogier Benigne's Book of Hours* of circa 1500 (FIG. 20) could see the Host and reap its benefits even outside of the liturgical setting of the Mass, in their personal prayers.

The Host of Dijon was believed to have miraculously bled, thus authenticating itself as Christ's true body and blood; it was a relic, imbued with holy presence.[40] This blood reminded the viewer of Christ's suffering human body, an association that was made each time his sacrifice on the cross was ritually reenacted during the Mass. The artist of the Benigne page further expanded upon the connection between the dead Christ and the Eucharist by including angels who elevate the bleeding Host in a gesture reminiscent of that of the priest at the ritual moment of the Host's transubstantiation, a gesture signaling Christ's true presence. In fact, the bleeding Host is interchangeable with the wounded and sacrificed Christ, where presentation in imagery—as, for example, the Smart Museum's *Deposition* (FIG. 21)—recalls again the ritualistic offering of the Host. Related motifs appear repeatedly in images of the Eucharist and the Passion: a page from a sixteenth-century

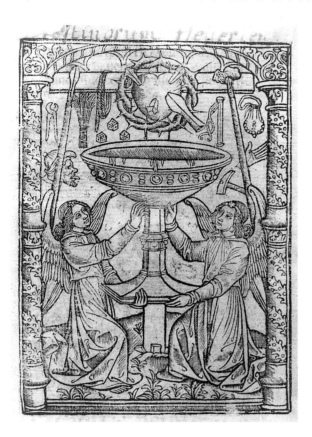

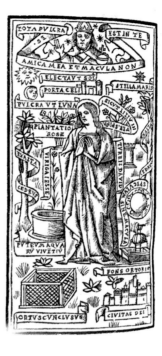

FIG. 22

French (Paris),

Missale itineratium: Angels with

Symbols of the Passion, 1517

(Cat. no. 14)

FIG. 23

Italian (Venice),

printed in German,

Breviary: Virgin Mary in the

Garden of Purity, 1518

(Cat. no. 45)

missal (FIG. 22) shows angels holding up a chalice dripping with blood and surrounded by the instruments of the Passion (*arma Christi*), suggesting that the seeping eucharistic vessel, along with the wounded Sacred Heart encircled by the crown of thorns, are surrogates for the suffering body of Christ. The *Farnese Reliquary* (FIG. 19) is decorated with similarly positioned angels, perhaps indicating that its primary function (before its significant and not fully documented reworkings) was as a monstrance.[41] Indeed, though saintly bodies remained a principal focus of religious practice, the Eucharist began to displace them in the later Middle Ages.[42] In his early fifteenth-century text *Imitatio Christi*, Thomas à Kempis criticized those who traveled far and wide to behold saintly relics and pray for their intercession, when communication with God could be directly attained.[43] By meditating on Christ's Passion through the Eucharist, devotional texts, and new imagery, the faithful could identify with Christ's humanity and thus achieve direct access to the divine.

The late medieval concentration on Christ the man led to a devotional and artistic focus on episodes from his life that featured his most vulnerable human moments: the Nativity and the Passion, Christ's birth and death. Because the Virgin Mary was the sole source of flesh for God incarnate, her image proliferated (FIG. 23) and was often manipulated to underscore this bodily association.[44] Luca Cambiaso's *Madonna and Child with Saint John the Baptist and Saint Benedict* emphasizes the affectionate and human relationship between the Virgin and her son (COLOR PLATE 8).[45] Cambiaso drew upon late medieval *sacre conversazioni* ("sacred conversations"), images in which a playful, human Christ child sits atop his mother's altarlike lap in the company of faithful saints.[46] Taking cues from his late medieval and early Renaissance forbears, Cambiaso accentuated Mary's role as intercessor. The devoted spectator is drawn into the scene through the Virgin's loving embrace of her restless child, and through her emotive expression.

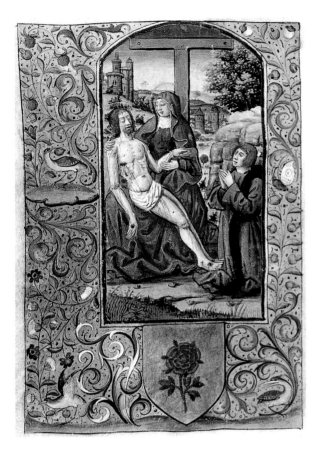

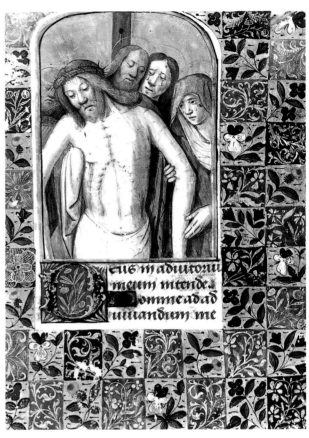

FIG. 24

French, *Book of Hours,*
Use of Paris: Donor before
the Pietà,
circa 1500–1510
(Cat. no. 42)

FIG. 25

French, Workshop of
Jean Bourdichon,
Book of Hours, Use of Rome:
Man of Sorrows,
circa 1490
(Cat. no. 34; f. 95r,
not in exhibition)

Just as the monstrance was a reliquary containing Christ's body, so Mary was often described as a sacred vessel, and links between the historic Christ Child and the ceremonial sacrament of the Mass were profound.[47] The proliferation of eucharistic tabernacles featuring images of the Madonna and Child, and of late medieval eucharistic miracles in which the Host appears as a baby, often mutilated and bloody, to exceptionally devout (almost exclusively female) visionaries demonstrate this association.[48] If the Eucharist—the torn and consumed body and blood of Christ—referred primarily to his sacrifice, these visions of the child in the Host explicitly linked the Nativity to the Passion. Indeed, in the art and literature of the late Middle Ages and Renaissance, this connection was emphasized by foreshadowing Christ's death at his birth, with new imagery and visual clues such as the Paschal Lamb in Cambiaso's painting.[49] In addition, depictions of the *Pietà*, the dead adult Christ lying in his mother's arms (FIGS. 24 and 42), recall tender representations of the Madonna and Child such as that by Cambiaso.

The *Pietà*, as a scene without a larger scriptural context, was part of a new, symbolic and timeless (rather than narrative) iconography of the Passion that developed around the turn of the fourteenth century. Its eucharistic implications and appeal to the viewer's compassion generated deep religious devotion and tremendous pity for the sacrificed Christ. The tears of the witnesses to Christ's bloody torture and death in many medieval images indicate the expected response of the faithful viewer (FIG. 25). Despairing expressions and gestures in early modern paintings like Anton Raphael Mengs's *Lamentation* (FIG. 26) evoke this medieval tradition, as do the eucharistic implications of the scene: a figure carefully supports Christ's bleeding, sacrificed body with a cloth, recalling the way in which the conse-

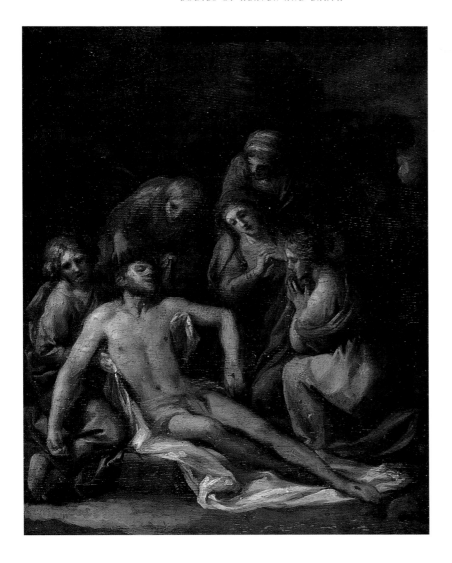

FIG. 26 .
Anton Raphael Mengs,
Study for the Rinucci Lamentation,
1779 (Cat. no. 36)

crated Host, which could not be directly handled, would be offered by the celebrant at the Mass.[50]

The association of late medieval Passion imagery with the Eucharist is literalized, and the doctrine of transubstantiation confirmed, in popular images of the Mass of Saint Gregory, in which Christ, in response to a prayer by Gregory the Great, proves the authenticity of the Eucharist to a skeptical woman (FIGS. 27 and 40). Typically, Christ as the Man of Sorrows appears above the altar, the wound in his side shooting blood into the chalice before a reverent Gregory. The liquid that will be consumed by the congregants is thus literally the blood that Christ shed for their salvation. The Mass of Saint Gregory and the related and similarly popular Man of Sorrows (FIG. 28), the frontal image of a forlorn and bloody Christ whose artistic prototype was a miraculous Byzantine icon, generally accompanied eucharistic prayers in late medieval Books of Hours.[51] As Caroline Walker Bynum argues and these images make clear, it was in Christ's suffering humanity and not in his triumph and Resurrection that the faithful of the late Middle Ages found their identification and unity with Christ.[52] He was redemptive food to be consumed—the ultimate assimilation with his human flesh.

FIG. 27
French (Paris),
Missale itineratium:
Mass of Saint Gregory,
1517 (Cat. no. 14)

In late medieval texts, such as the late thirteenth- or early fourteenth-century Franciscan *Meditations on the Life of Christ*, the wound in Jesus' side features prominently as the site of all of his suffering and thus the essence of his humanity. Meditation on Christ's body was an important aspect of devotion to the Passion (itself the primary focus of late medieval "affective piety"), and his wounds consequently became the central objects of reverence. The cult of the Five Wounds—referring to the wounds in his hands, his feet, and his side—led to a proliferation of images showing the fragmented parts of Christ's bleeding body (FIG. 29) as well as to the development of prayers addressing each wound.[53] Some of these texts exhorted viewers to touch, kiss, and enter Christ's wounds as a means of understanding the Passion and accessing the divine. Indeed, images of the "Doubting Thomas," the apostle who questioned accounts of the Resurrection until he actually touched Christ's wounds, offer a saintly prototype of these medieval devotional practices (FIG. 50). The pictorial dismemberment of Christ's body in representations of the Five Wounds reinforces the eucharistic notion, also central to the cult of saintly relics, that each part stands in for—indeed *is*—the whole.[54] Through this imagery and these prayers, the faithful concentrated in isolation on each part in order to comprehend the entire story of the Passion. With a similar purpose, images of the *arma Christi* (themselves venerated relics) condensed the events of the Passion into a bundle of instruments, gathering a complex narrative into a single, meditative image (FIGS. 22 and 28).

FIGS. 28 AND 29
Flemish (Bruges),
Book of Hours, Use of Salisbury:
Man of Sorrows (above) and
Christ's Wounds (below), circa 1455
(Cat. no. 35)

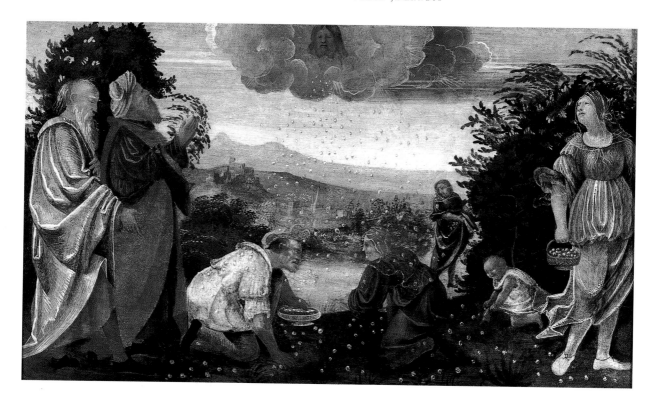

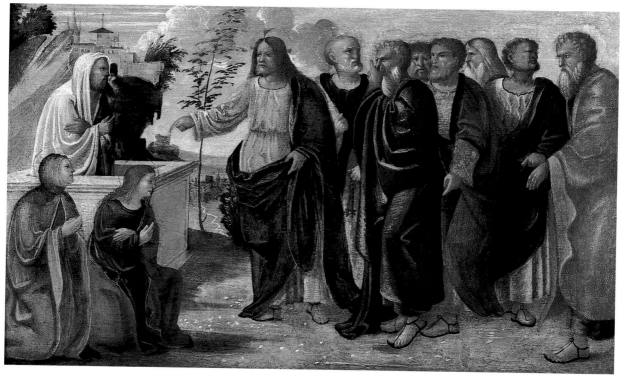

FIGS. 30 AND 31

Bartolommeo Suardi (called Bramantino),
The Gathering of Manna and *The Raising of Lazarus*,
1505–1506 (Cat. nos. 30 and 31)

FIG. 32
Italian (Venice),
printed in German,
*Breviary: Prayers for
Pentecost Eve*, 1518
(Cat. no. 45)

Bodies permeated medieval Christianity. They were objects of veneration and sites of access to the everlasting. Through the functions and travails of these bodies, devoted Christians sought, and often achieved, communication with the divine. Saints and martyrs—people who had lived piously and died in defense of their faith—represented the sacred promise of perfect bodily resurrection, a promise reconfirmed in relics and reliquaries and in images of martyrdoms and the life of Christ. Biblical narratives were understood to foretell this phenomenon: the Raising of Lazarus (FIG. 31), the story of Christ's miraculous revival of a dead man, was read as prophetic of Christ's own resurrection and, by extension, of the glorified aura of saintly relics. Similarly, the Old Testament episode of the Gathering of Manna (FIG. 30) foretold the fundamental events of Christ's life, death, and resurrection in its basic assertion that God would provide sustenance to his flock.[55] A series of marginal illustrations in a sixteenth-century breviary make this association more overtly. Here, the Gathering of Manna appears amidst several eucharistic scenes, including a representation of the Last Supper and an image of Christ filling a chalice with his own blood (FIG. 32). In the Christian era, God's love was even greater than it had been when he miraculously showered the wandering, hungry Israelites with manna; the food he provided now, as spiritual rather than physical sustenance, was his own flesh and blood, offered up upon the cross. It was through the literal and metaphoric consumption of this sacrifice that medieval Christians made their way toward heaven.

NOTES

1. Cited in Peter Brown, *The Cult of the Saints: Its Rise and Function in Latin Christianity* (Chicago: University of Chicago Press, 1981), 11.

2. Brown, 50.

3. The Greek word *stephanos* means crown, and the late medieval hagiographer Jacobus de Voragine described Stephen, who was the first martyr under the New Testament, as the "crown of the martyrs" and the "Protomartyr." See Voragine, *The Golden Legend: Readings on the Saints*, trans. William Granger Ryan (Princeton, N. J.: Princeton University Press, 1993), vol. 1, 45 ff., and vol. 2, 40 ff.

4. For a discussion of an earlier depiction of this saint's martyrdom, a fresco cycle at Saint Stephen's Oratory, Saint-Germain, Auxerre (ca. 870), see Cynthia Hahn, "Seeing and Believing: The Construction of Sanctity in Early-Medieval Saints' Shrines," *Speculum* 72, 4 (October 1997): 1101–02.

5. For accounts of these miracles, see Jonathan Sumption, *Pilgrimage: An Image of Mediaeval Religion* (Totowa, N.J.: Rowman and Littlefield, 1975), 26; Patrick J. Geary, *Furta Sacra: Thefts of Relics in the Central Middle Ages* (Princeton, N. J.: Princeton University Press, 1978), 142; and Voragine, vol. 1, 48 ff., and vol. 2, 42 ff.

6. Augustine, *Concerning the City of God against the Pagans*, trans. Henry Bettenson (London: Penguin Books, 1972), 1041 ff.; Caroline Walker Bynum and Paula Gerson, "Body-Part Reliquaries and Body Parts in the Middle Ages," *Gesta* 36, 1 (1997): 3.

7. See, for example, Bynum, "The Body of Christ in the Later Middle Ages: A Reply to Leo Steinberg," in *Fragmentation and Redemption: Essays on Gender and the Human Body in Medieval Religion* (New York: Zone Books, 1991).

8. Cited in Raymond of Capua, *Life of Saint Catherine of Sienna* [sic], *by the Blessed Raymond of Capua, Her Confessor*, trans. E. Cartier (Philadelphia: Peter F. Cunningham, 1859), 350.

9. In Voragine, vol. 2, 338.

10. For a general overview of this artist, see Marina Magrini, *Francesco Fontebasso (1707–1769)* (Vicenza: Neri Pozza Editore, 1988).

11. See Geary, esp. 4, 38, 74, 137–38.

12. Voragine, vol. 2, 339. As with all accounts of saints' lives, there are several different versions of how Catherine's body actually did make its way to Mount Sinai. See Agnes B. C. Dunbar, *A Dictionary of Saintly Women* (London: George Bell and Sons, 1904), 150.

13. Although the term "manna" was originally used in the Hebrew Bible (Exod. 16:11–18) to refer to the miraculous food that God showered on the hungry Israelites (see fig. 30), in the Middle Ages it also came to signify other, specifically Christian substances, such as holy dust, food, or excretions. In his chapter on "The Prodigious Manna," Piero Camporesi discusses the healing "manna" that was exuded from holy Christian bodies "as a token of [the saints'] pleasure at the entreaties addressed to [them]"; Camporesi, *The Incorruptible Flesh: Bodily Mutation and Mortification in Religion and Folklore*, trans. Tania Croft-Murray (Cambridge: Cambridge University Press, 1988), 7. Brown, 105, mentions how Saint Stephen's relics "scattered sweet manna on the hillside," and Maggie Duncan-Flowers discusses how the "manna" produced on the tomb of Saint John the Evangelist on his feast day served as evidence for medieval pilgrims of his vital presence there and his willingness to act as intercessor and healer; Duncan-Flowers, "A Pilgrim's Ampulla from the Shrine of St. John the Evangelist at Ephesus," in *The Blessings of Pilgrimage*, ed. Robert Ousterhout (Urbana: University of Illinois Press, 1990), 125–39.

14. Voragine, vol. 2, 339.

15. For further discussion of these saintly emissions, see Sabine MacCormack, "Loca Sancta: The Organization of Sacred Topography in Late Antiquity," in *The Blessings of Pilgrimage*, esp. 21.

16. Peter Grossman, in *The Coptic Encyclopedia*, ed. Aziz S. Atiya, vol. 1 (New York: Macmillan, 1991), 24.

17. For a discussion of pilgrimage ampullae, see Karl Sandin, "Liturgy, Pilgrimage, and Devotion in Byzantine Objects," *Bulletin of the*

Detroit Institute of Arts 67, 4 (1993): 49; and
Duncan-Flowers, 126.

18. The crypt's guardian (*oecumenos*) uses this term; see Hahn, 1088–90.

19. Geary, 17, defines the "central Middle Ages" as the ninth through eleventh centuries—a time, he says, when the cult of relics was at its peak.

20. While Christ was a source of sacred power in himself, saints and their relics served as intercessory vehicles to the divine. This notion is illustrated in the tympanum outside the church at Conques, which housed the miraculous relics of Saint Foy in a precious reliquary in the shape of her body. A detail of the Last Judgment tympanum shows Saint Foy genuflecting before God's hand; she is shown as being alive in her relics, serving as a channel to God—not to be worshiped for her own sake.

21. Cartier, 411, describing the fate of Saint Catherine of Siena's body after her death.

22. See Bynum, *The Resurrection of the Body in Western Christianity, 200–1336* (New York: Columbia University Press, 1995); Bynum, "Material Continuity, Personal Survival and the Resurrection of the Body: A Scholastic Discussion in Its Medieval and Modern Contexts," in *Fragmentation and Redemption*; Ellen M. Shortell, "Dismembering Saint Quentin: Gothic Architecture and the Display of Relics," *Gesta* 36, 1 (1997): esp. 39–40; and Paul Binski, *Medieval Death: Ritual and Representation* (Ithaca, N.Y.: Cornell University Press, 1996), esp. 12.

23. See Ellert Dahl, "Heavenly Images: The Statue of St. Foy at Conques and the Signification of the Medieval 'Cult Image' in the West," *Acta* 8 (1978): 175–91.

24. Even though these types of reliquaries did not always carry the body part depicted, the name "speaking reliquaries" refers to the idea that the shape of the reliquary expresses or "speaks" its contents. See Bynum and Gerson, 4.

25. Cited in Claire Wheeler Solt, "Romanesque French Reliquaries," *Studies in Medieval and Renaissance History* 9 (1987): 182.

26. The provenance of this head is unclear, but it may be discussed as an exemplar of a reliquary type. It resembles the fourteenth-century bust of Saint Agapit, church of Tauriac, and the twelfth-century head of Saint Candidus, Saint-Maurice d'Agaune, Abbey Treasury. Regarding provenance, the Heim Gallery notes that since the reliquary is said to have come from a community of nuns, and no mention of it has been found in histories or guides to the northern Italian area where it probably originated, it "may always have been within the *clausura*, and so not seen by the public or described" (Heim Gallery fact sheet, 2, Minneapolis Institute of Art archive).

27. Bynum, "The Female Body and Religious Practice in the Later Middle Ages," in *Fragmentation and Redemption*, 235; and Sumption, 24.

28. Scott B. Montgomery discusses the practice of kissing reliquary busts in "*Mittite capud meum . . . ad matrem meam ut osculetur eum*: The Form and Meaning of the Reliquary Bust of St. Just," *Gesta* 37, 1 (1997): 51–52.

29. Lucy Menzies, *The Saints in Italy: A Book of Reference to the Saints in Italian Art and Dedication* (London: William Brendon and Son, 1924), 427.

30. See Binski, 78.

31. Meg Craft, Conservation Report (Baltimore, September 30, 1999, Smart Museum archive), 2–3. Craft notes that the entire reliquary chamber may not be original (one theory is that the compartment was originally smaller), but that, in any case, it did have transparent windows. For a technical discussion regarding the problems of dating the reliquary, see Craft, 1–12. The various modifications to this vessel make identification of its original contents difficult; it seems likely that its first function was to house the Host, and that only later did it serve as a saintly reliquary. The images on the surviving églomisé, of the Coronation of the Virgin and of the Virgin bestowing palms of martyrdom on a gathering of saints, suggest that at one point it held a relic associated with Mary.

32. On ostensoria and the viewing of relics, see Charles Zika, "Hosts, Processions and Pilgrimages: Controlling the Sacred in Fifteenth-Century Germany," *Past and Present*, no. 118 (February 1988): 46; and Kathleen Biddick, "Genders, Bodies, Borders:

Technologies of the Visible," in *The Shock of Medievalism* (Durham, N.C. and London: Duke University Press, 1998), 154.

33. Numerous scholars note this shift toward the faculty of sight in late medieval communication with the divine. See Binski, esp. 78; Michael Camille, "The Image and the Self: Unwriting Late Medieval Bodies," in *Framing Medieval Bodies*, ed. Sarah Kay and Miri Rubin (Manchester and New York: Manchester University Press, 1994), esp. 77; Miri Rubin, *Corpus Christi: The Eucharist in Late Medieval Culture* (Cambridge: Cambridge University Press, 1991), 150; Sarah Beckwith, *Christ's Body: Identity, Culture and Society in Late Medieval Writings* (London and New York: Routledge, 1993), 36; Zika, 30–33; Biddick, 154; and Bynum, "Material Continuity," 271. See also Stephanie Leitch's essay in this catalogue.

34. For Pope Paul III, see Mary Jackson Harvey, catalogue entry in *The David and Alfred Smart Museum of Art: A Guide to the Collection*, ed. Sue Taylor and Richard A. Born (New York: Hudson Hills Press, 1990), 39; for Alessandro Farnese, see Mario Pereira, catalogue entry in *The Place of the Antique in Early Modern Europe*, ed. I. D. Rowland (Chicago: The David and Alfred Smart Museum of Art, 1999), 53–56.

35. See Margaret English Frazer, "Reliquaries," *The Metropolitan Museum of Art Bulletin* 43, no. 3 (winter 1985/86): 51 and 54.

36. See Rubin, *Corpus Christi*, 290–91.

37. For a discussion of this controversy, see Sumption, esp. 42–48.

38. See Zika, esp. 30–33; Rubin, *Corpus Christi*, esp. 150 and 289 ff; Beckwith, 36; Bynum, "Women Mystics and Eucharistic Devotion in the Thirteenth Century," *Women's Studies: An Interdisciplinary Journal* 11 (1984): esp. 186; and Richard Kieckhefer, *Unquiet Souls: Fourteenth-Century Saints and Their Religious Milieu* (Chicago: University of Chicago Press, 1984), esp. 171.

39. Rubin, *Corpus Christi*, 150 and 64; Zika, 33.

40. For a discussion of the miraculous bleeding Host of Dijon and its anti-Semitic implications (this Host, like many others in the late Middle Ages, was said to have miraculously bled as a sacred response to a blasphemous and "hateful" Jewish attack), see Rubin, *Gentile Tales: The Narrative Assault on Late Medieval Jews* (New Haven, Conn.: Yale University Press, 1999), 162–69.

41. See n. 31, above.

42. See Zika, and Geary, esp. 28–30.

43. Rubin, *Corpus Christi*, 318.

44. Kieckhefer, 165 ff. Bynum, "Jesus as Mother and Abbot as Mother: Some Themes in Twelfth-Century Cistercian Writing," in *Jesus as Mother: Studies in the Spirituality of the High Middle Ages* (Berkeley: University of California Press, 1982), esp. 137.

45. Cambiaso, a Genoese painter, was awarded many religious commissions and is perhaps best known for his altarpieces and fresco decorations in the Escorial monastery in Spain. For further discussion of this artist, see Bertina Suida Manning and W. E. Suida, *Luca Cambiaso: La Vita e le opere* (Milan: Casa Editrice Ceschina, 1958).

46. For a discussion of medieval images of the Virgin and Child, particularly regarding the emphasis on the Incarnation and eucharistic implications, see Rubin, *Corpus Christi*, 142–47.

47. Bynum, "Women Mystics," 204. Bynum cites Dumoutet, who quotes canonist and writer William Durandus (1237–96). Durandus wrote in his *Rationale* that the reliquary (*capsa*) into which one puts the consecrated Host *is* the body of Mary (see "Women Mystics," 214, n. 121). Bynum also mentions actual monstrances shaped like the Virgin's body, with the consecrated wafer held and displayed in her "womb"; see "The Female Body," esp. fig. 6.10.

48. For discussion of such miracles, see Rubin, *Corpus Christi*, 116–135 ff., and 344; and Kieckhefer, 171.

49. See Kieckhefer, 106.

50. See Michael Camille, "Mimetic Identification and Passion Devotion in the Later Middle Ages: A Double-Sided Panel by Meister Francke," in *The Broken Body: Passion Devotion in Late Medieval Culture*, ed. A. A. MacDonald, H. N. B. Ridderbos, and R. M. Schlusemann (Groningen: Egbert Forsten, 1998), 192.

51. For a summary of the story of the Mass of Saint Gregory, see Sumption, 44–45. For the origin of the Man of Sorrows type and its

development in the late Middle Ages, see Camille, "Mimetic Identification," 187; for a general overview of the type, see Rubin, *Corpus Christi*, 308–10. Because of its concentration on Christ's suffering humanity (the primary concern of late medieval Christians), the Man of Sorrows became popular and appeared in diverse settings throughout Europe. Zika argues that the proliferation of eucharistic images such as the Man of Sorrows signaled the Host's preeminence above saintly relics in late medieval devotion.

52. Bynum, *Holy Feast and Holy Fast: The Religious Significance of Food to Medieval Women* (Berkeley: University of California Press, 1987); see also Bynum, "The Body of Christ," "The Female Body," "Jesus as Mother," and "Women Mystics."

53. See David S. Areford, "The Passion Measured: A Late-Medieval Diagram of the Body of Christ," in *The Broken Body*, 211–38; Dom Louis Gougaud, *Devotional and Ascetic Practices in the Middle Ages*, English prepared by G. C. Bateman (London: Burns Oates and Washbourne, Ltd., 1927), 8off.; Flora Lewis, "The Wound in Christ's Side and the Instruments of the Passion: Gendered Experience and Response," in *Women and the Book: Assessing the Visual Evidence*, ed. Lesley Smith and Jane H. M. Taylor (Toronto and Buffalo: University of Toronto Press, 1997);

Karma Lochrie, "Mystical Acts, Queer Tendencies," in *Constructing Medieval Sexuality*, ed. Karma Lochrie, Peggy McCracken, and James A. Schultz (Minneapolis: University of Minnesota Press, 1997); Rubin, *Corpus Christi*, 303–6; Kieckhefer, 108.

54. Bynum, "Material Continuity," 280; Bynum, *The Resurrection of the Body*, esp. 316; Areford, 227; Rubin, *Corpus Christi*, 304; and Sumption, 28.

55. The linking of Old Testament tales with their fulfillment in the New Testament was often achieved in medieval and Renaissance art through the juxtaposition of corresponding episodes taken from each source. This common practice might provide a clue to the original arrangement of Bramantino's two paintings (figs. 30 and 31). It has been noted that these works were "intended as predella panels" (F. R. Shapley, *Paintings from the Samuel H. Kress Collection, Italian Schools, XV–XVI Century* [New York: Phaidon Press, 1968], 19), and their subjects relate them appropriately to a main panel with a eucharistic theme, such as the Last Supper. For specific ways, particularly through prayers, sermons, and artistic devices, that the biblical "manna" episode was expressed in this period as a forerunner to the Christian eucharist, see Rubin, *Corpus Christi*, 20, 106–8, 129–31, 146, 216, 230, and 316.

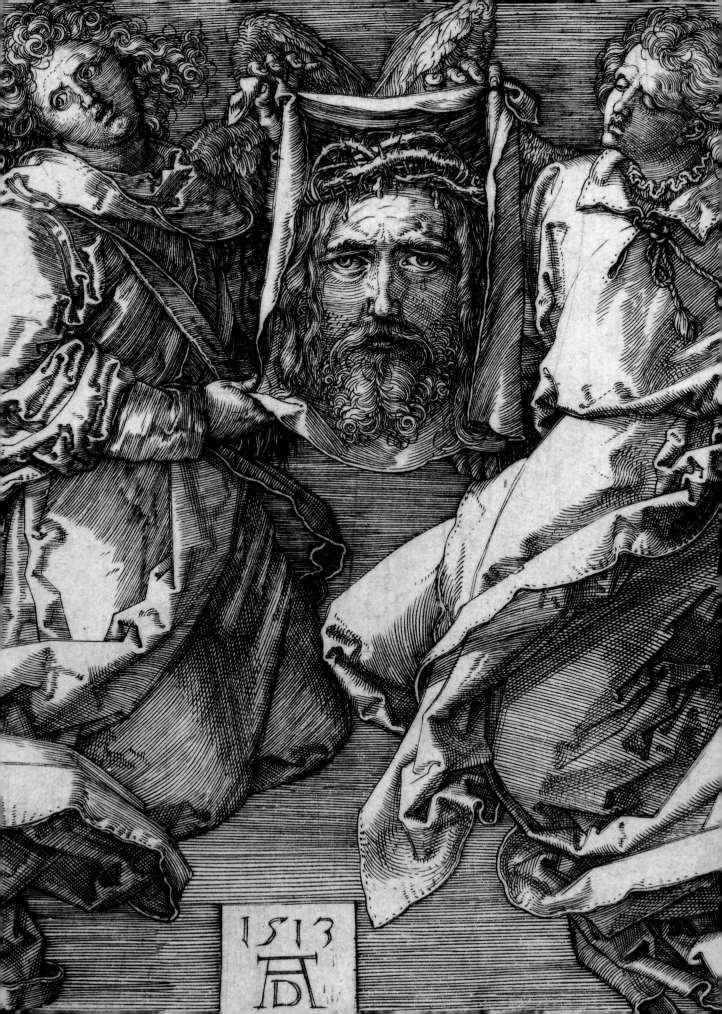

Seeing Objects in
Private Devotion

he objects of piety are both tools and artworks, their ritual utility shifting in response to changing theological imperatives and their aesthetic status bound up with notions of the power of vision as a force for good and evil. From the earliest Christian centuries, pious lay persons employed visual cues in their devotional practices, often in the form of amulets, in order to summon supernatural forces. Such efforts disclose an ardent desire to contemplate those martyrs of the Church who were known to have achieved unmediated encounters with God. Illuminated manuscripts of a later period show us lay people optimistically trying to evoke visions of saints; with concentrated meditation, a supplicant attempts to make the spectral presence of the

STEPHANIE LEITCH

43

object of his or her devotion appear immediately at hand. Toward the close of the Middle Ages, theological concern focused on the humanity of Christ and imagery emphasized new iconographic themes, such as the Man of Sorrows and the Virgin Mary as mother and intercessor. Practices and objects of devotion changed again with the Reformation when emerging mechanical technologies regularized visionary imagery and made it available in previously unknown ways, disseminating it to a far larger audience than had ever before been possible. Drawing from a broad range of examples and spanning several centuries, this essay traces shifts in the ways objects were seen and by extension used in devotional practices. In its non-linearity, this trajectory reveals, among other things, the enduring power of vision and the variety of its objects.

In the Early Christian and medieval periods, as a continuation of pagan practices, the laity sought methods for summoning good spirits and keeping bad ones away. Of all the senses people might use to commune with the world of supernatural powers, sight was considered particularly potent because of the reciprocity it afforded with the divine: sight was a human faculty understood to be shared by God. The difference between human and divine sight was one of degree rather than kind. According to fifteenth-century theologian Nicholas of Cusa, God's sight described a circle and so was absolute. Compared to the "all-seeingness" of God, humans could only see through a finite angle. Demons could see, too, and through this faculty they battled to undermine the fortune of a soul under God's watchful gaze. The physical displacement of evil forces was necessary in order that a Christian house be fit for contemplative worship. Private devotion during this period incorporated pagan prescriptions for avoiding evil, most notably prescriptions that were activated through sight and seeing.

The power of the gaze to fascinate or bewitch underlay many superstitious beliefs. Not until the Renaissance was sight subject to quasi-scientific scrutiny or logical deduction, and even then the gaze retained an aura of power. The ambivalent nature of the gaze meant that there were both right and wrong types of looking. A gaze motivated by envy could threaten its object. In Greek mythology, Narcissus looked a little too closely at his own image and was transformed into a flower; his example warns of the capacity of the admiring gaze to negatively transform. The "evil eye" was the physical manifestation of an envious glance that could bring potential ruin to its target.[1]

A number of formulae governed the successful deflection of the evil eye, and in Syria, Palestine, and Egypt apotropaea—objects employed in the averting of evil—took many forms. Mirror plaques are small decorative plaques of clay, framing polished glass, that were displayed in homes or buried in tombs.[2] These objects turned the evil force back on itself by means of their reflective surfaces. Such plaques have been excavated in an array of cultural contexts, leading scholars to believe that they were not exclusive to specific religious practices and were probably devices to ward off the evil eye.[3] The Smart Museum's terracotta plaque (FIG. 33) is a fifth- to sixth-century example. The large circular impression in the top triangular section, as well as the smaller circles that flank it, probably held mirrors.[4] Myths justified the potency vested in mirrors based on their properties of reflection. In the most famous example, Perseus approached Medusa without gazing directly at her but by looking instead at her reflection in his bright bronze shield.

A related method for foiling evil forces was to attract the hostile gaze to a bright or dazzling object in order to distract it from its intended victim. Yet another remedy prescribed confusing it by directing its focus toward an insoluble problem. In some cases, inscriptions on amulets summoned benevolent spirits for protection, while others bore pseudo-inscriptions that, it was hoped, would portend danger and thus scare off the evil eye.[5]

A sixth- or seventh-century pendant intended for popular use (FIG. 34) carries a depiction of the "much suffering eye" beneath an apotropaic text. This visual trope showed the eye

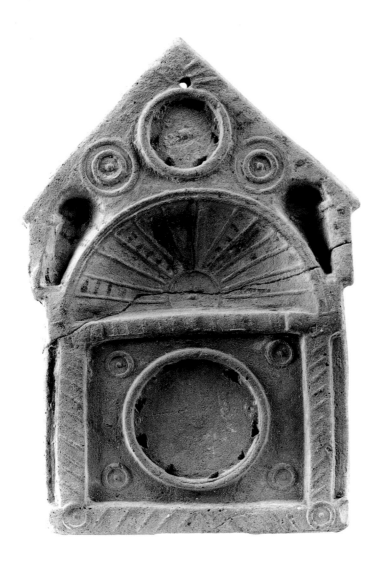

FIG. 33
Early Christian,
Votive or "Evil Eye" Plaque,
5th–6th century
(Cat. no. 2)

literally being attacked by a host of pernicious forces: animals, tridents, scorpions, birds, beasts, and, as in this case, daggers and spears. The designation "much suffering eye" derives from the Testament of Solomon, a popular magical treatise incorporating Jewish and Christian elements. According to the legend, the Archangel Michael gave King Solomon an engraved stone set in a ring sent by Lord Sabaoth. The ring could evoke demons and force them to reveal the incantation or device that would thwart their powers. When the evil eye demon Rhyx Phthenoth was summoned, he announced: "I cast the glance of evil at every man. My power is annulled by the engraved image of the much-suffering eye."[6]

These Early Christian objects carried valences of superstition that would ultimately be frowned on by the Church. The early Church fathers searched sacred texts for proscriptions against the practice of maleficent arts.[7] If the evil eye existed, they reasoned it was probably cast by demons working through human hosts with like purposes. The patristic writers betrayed their debt to pagan thinkers in their continued belief that man's fortune could lie in the ambush of envious supernatural forces. The logistics of physical transmission continued to perplex them as they tried to grasp how the evil eye could assail the vulnerable from

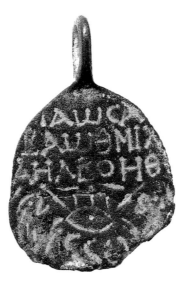

FIG. 34
Byzantine,
Holy Rider Pendant (reverse),
6th–7th century
(Cat. no. 4)

a distance. The pagan writer Democritus defended the eye's power to poison through the transmission of atomic particles. John Chrysostom, a prominent late fourth-century doctor of the Greek church, believed that the eye was a passive instrument through which what is seen flows into the soul. Eusebius of Alexandria, an ecclesiastical writer of several popular sixth- and seventh-century homilies, tried to shift the source of evil to the devil, who led men to blame their misfortunes on each other. Eusebius maintained that the form of the cross was man's shield against the *fascinatio* of the devil.[8] Within Christian contexts, apotropaea that protected against the envious glance of humans were replaced by amulets designed to assail the devil directly.

As part of an outgrowth of this sense that the eye is a source of special power, many objects created for private Christian devotion mediate the act of vision. They functioned as aids to conjuring visions, but did so in order to achieve a direct encounter with God. Representations of the Saint Veronica legend illustrate how an image of God's eyes could provide a metaphor for his visual jurisdiction over humankind and become a focus for veneration. A fifteenth-century ivory pendant depicting Veronica's veil (FIG. 35) is an example of devotional jewelry of the type commissioned by wealthy patrons to be worn in part as a form of personal protection. In its frontality and symmetry, the image of Christ takes the form of a protective icon. This amuletic function is especially interesting because of the treatment of Christ's eyes, which theoretically operate like a mirror. On this pendant they seem blank or even closed, suggesting the power of divine vision as beyond the human and as privileged with an unobstructed view into the soul. That this sacred jewel has such strong connections with apotropaic imagery is a telling example of how the sense of sight continued to dominate Christian devotional practice.

The all-seeing eyes of Christ were of great theological importance, and up until the twelfth century Christ in the role of divine ruler or judge had been the focus of veneration. But the late Middle Ages witnessed a transformation in understandings of the nature of Christ. Mystical theologians, whose revelations spurred new practices of faith, ushered in a shift in emphasis from Christ's divinity to his human nature.[9] Christ's life on earth became a subject of devotion, and imitation of his life became an end in itself. The image of the *vera icon*, the "true image" of Christ, featured on the ivory pendant and in Albrecht Dürer's *Sudarium Displayed by Two Angels* (FIG. 36), testified to the Incarnation, even while the mirac-

FIG. 35

German,

Pendant: Veronica's Veil

(obverse),

15th century

(Cat. no. 8)

ulous origins of the image made it clear that Christ's human nature was in no way ordinary. It was an *acheiropoetoi*, an image generated "not by human hands." Veronica is said to have wiped the sweat from Christ's brow with her handkerchief as he made his way along the road to Calvary—thus *sudarium*, from Latin *suder*, "sweat."[10] The cloth retained a trace or imprint of Christ's face and was venerated as one of the rare Christological relics.

An early variant of the Veronica legend claims that her image of Christ was actually a painted icon. In this story, the image came into public consciousness thanks to its miraculous healing of Emperor Tiberius. Not until the circulation of a more popular account of the legend was the image actually thought to be a relic generated from the cloth's contact with the face of Christ. Hans Belting calls the first mention of Christ's face on the veil, in around 1216, either a miracle or a public relations maneuver whose marketability relied on the

FIG. 36

Albrecht Dürer,

Sudarium Displayed

by Two Angels, 1513

(Cat. no. 47a)

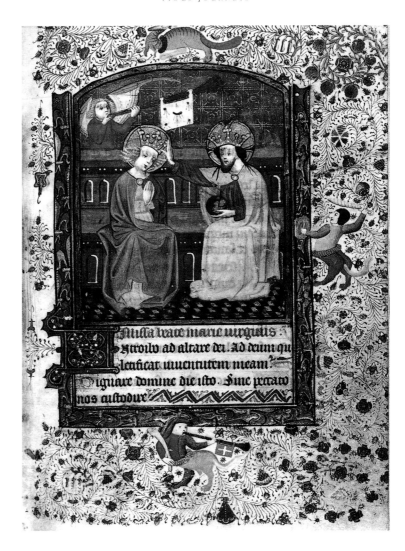

FIG. 37

Flemish, *Prayerbook of Margaret
of Croy: Coronation of the Virgin*,
circa 1435–1450 (Cat. no. 39,
f. 13r, not in exhibition)

presence of an actual face: in that year, the imprint of the face on the veil was reported to
have miraculously inverted itself during a papal procession. This sign was portentous enough
to sponsor both indulgences and the rise of a cult. The *sudarium* underwent a final change
around 1300, when it entered the repertoire of Passion imagery. In this iconographic con-
text, the head of Christ is encircled with a crown of thorns.[11] A miniature from the mid-
fifteenth-century *Prayerbook of Margaret of Croy* (FIG. 37) shows yet another variation of this
image: here the cloth bears the four stigmata and the laceration in Christ's side. The figure
of Christ was a later addition to this visual genealogy.

Nicolas of Cusa made the *vera icon* more accessible by prescribing instructions for its
use in contemporary devotion. In 1453 a group of Benedictines in the Tyrol requested of
Cusa a method for grounding their meditation.[12] He sent his reply to them in the form of a
book he entitled *The Vision of God*, which outlines the means for achieving a mystical and
unmediated union with God. Cusa entreated the monks to engage the vision of God through
their sense of sight. This act of devotion was to be facilitated by a frontal, iconic image of
Christ, like that on Veronica's veil, which he sent along with the book (but has since been
lost). He advised them to mount the icon on the wall and defied them to escape its gaze:

I send for your indulgence such a picture as I have been able to procure, setting forth the figure of an omnivoyant, and this I call the icon of God. This picture, brethren, ye shall set up in some place, let us say, on a north wall . . . and each of you shall find that, from whatsoever quarter he regardeth it, it looketh upon him as if it looked on none other. . . . ye will marvel how it can be that the face should look on all and each at the same time. For the imagination of him standing to eastward cannot conceive the gaze of the icon to be turned unto any other quarter, such as west or south . . . he will marvel at the motion of its immovable gaze.[13]

For Cusa the icon was a tool that grounded the act of meditation by engaging the duality of the gaze. His book is a series of accounts of the glimpse of God acquired through meditations on images. Cusa's justification for meditation on an icon of God follows from the mystical nature of God, who sees "omnivoyantly" from a point beyond time. God could see man, but could man see God? The potential inequality of this relationship raised the anxiety of devotees, who feared that the scope of God's responsibilities would leave them victims of his neglect. In Cusa's paradigm of the meditative process, the devotee not only hails God, but also has the power to make God "hail" him, ensuring each person the command of God's attention. Before he could see God, the devotee had to narrow the aperture of his gaze to bring God into focus. But God's gaze, by contrast, derives its universality from its very sphericity:

> Our sight, through the mirror of the eye, can only see that particular object toward which it is turned, because its power can only be determined in a particular manner by the object, so that it seeth not all things contained in the mirror of the eye. But Thy sight, being an eye or living mirror, seeth all things in itself. . . . But the angle of Thine eye, O God, is not limited, but is infinite, being the angle of a circle, nay of an infinite sphere also, since Thy sight is an eye of sphericity and of infinite perfection. Wherefore it seeth at one and the same time all things around and above and below.[14]

Because his eye functions as a mirror, God is able to see all that can be reflected in that mirror, in other words, all people at all times.[15] But when man gazes back at God, it appears to him that he is looking in a mirror:

> When someone looks into this Mirror, he sees his own form in the Form of forms. . . . And he judges the form seen in the Mirror to be the image of his own form, because such would be the case with regard to a polished material mirror. However, the contrary thereof is true, because in the Mirror of eternity that which he sees is not an image but is the Truth, of which the beholder is the image.[16]

According to Cusa the eyes of God represented in the *vera icon* essentially function as a mirror in which the Truth is reflected. Thus the tools with which the medieval Christian looked for God were activated in much the same way as were pagan charms that warded off the evil eye. The *vera icon* acts as a surface which reflects the image of the Truth back to the beholder.

The proliferation of images such as those representing Veronica's veil attests to the rise of private devotion around cultic images and cult figures. The idea of accelerating one's own salvation through the accumulation of indulgences (or payments taken by the Church for the remission of sins in purgatory), advanced the notion of taking one's spiritual life into one's own hands. In the twelfth century, prayers said before either a relic or an image of Veronica's veil earned an indulgence of ten days. By the fifteenth century, the indulgence had increased to ten thousand days.[17]

Meditation dominated lay worship in pre-Reformation Europe; the premise behind successful meditation was the concentrated engagement of the senses and particularly the sense of sight, which, it was hoped, could induce in the devotee a mystical vision not unlike those visited on the saints. If eternity was a permanent vision of God, the practice of Christian meditation represented a hope for a "preliminary vision of God."[18] Another end of private devotion was to direct the supplicant to embrace a life of piety and humility modeled on that of Christ. Because images instructed by example and by empathy, if the devotee could *visualize* the sorrows of Christ, he or she was halfway on the path to imitation.

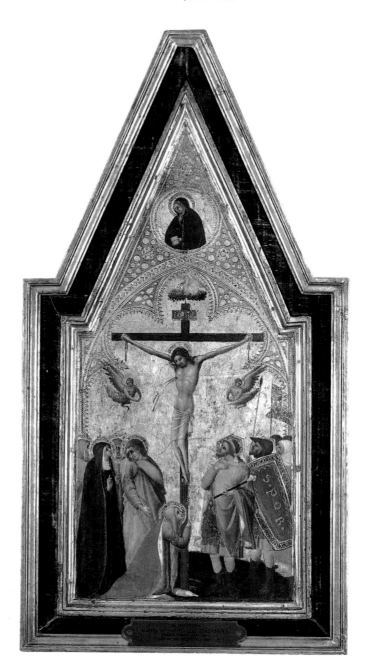

FIG. 38
Artist Unknown,
Italian, Sienese School,
The Crucifixion, circa
1350 (Cat. no. 11)

Episodes of Christ's life, replete with metaphorical weight, formed the visual aids to Christological devotion. Both the Smart Museum's fourteenth-century Sienese crucifixion panel (FIG. 38/COLOR PLATE 6) and the Martin D'Arcy Museum's mid-sixteenth-century crucifixion polyptych (FIG. 39) were portable altars, convenient for private devotion. The Sienese panel was probably once the right wing of a diptych, a double-sided hinged altar that stood when opened up;[19] the wings of the polyptych fold inward to form a protective portable case. Both examples invite meditation on the Passion of Christ, a sequence of events that doubled as a concretization of the eucharistic rite.[20] The Smart Museum's *Crucifixion* invites the viewer to contemplate the mystery of Christ's sacrifice, wherein his lifeless body will become the Host and the blood flowing from his side will be transformed

FIG. 39
German (sculpture) and
Netherlandish (painting),
Polyptych: The Crucifixion,
1500–1520
(Cat. no. 10)

into wine. The sculptor of the D'Arcy altar announced Christ as instrument of salvation even more palpably by having his crucified body protrude from the painted composition in the form of a free-standing sculpture. In creating this multimedia polyptych, the artist established a hierarchy of levels of experience. A painted backdrop of supplicants mirrors the viewer's role as prospective visionary. With the sculpted crucifix that protrudes into the viewer's dimension, the artist offered a premonition of the fruits of personal meditation. Hugging the base of the cross in both scenes is the Magdalene who, like the Virgin, was a common intercessory figure in depictions of the Crucifixion. The Magdalene served as a particularly cogent point of entry for the viewer: despite her human fallibility (a characteristic with which viewers could identify), she achieved sanctity and was thus an accessible example of true devotion to Christ.

An illuminated page from a late fifteenth-century French Book of Hours (FIG. 40) offers a vivid example of the ultimate goal of proper meditation. As Saint Gregory performs the ritual of blessing the Eucharist, he has a vision of Christ as Man of Sorrows. Nearby, an angel holds the *sudarium*. Three embodiments of Christ crowd this scene: the Host, the Man of Sorrows, and the *vera icon*. Gregory's vision served as proof of the consubstantiation, or the material simultaneity, of Christ's human form and his divine nature, for the consecration of the Eucharist calls up an image of the body of Christ. Defenders of transubstantiation—the sacramental transformation of the Host into the body of Christ—relied on miracles or

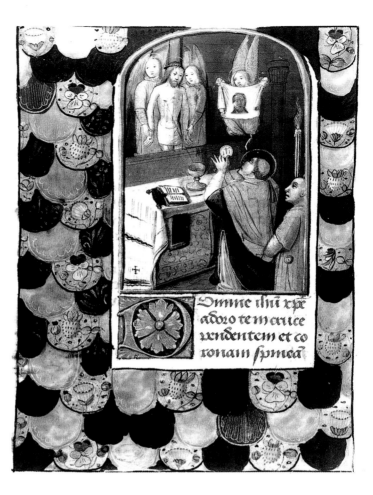

FIG. 40

French, Workshop of
Jean Bourdichon,
*Book of Hours, Use of Rome: Mass
of Saint Gregory*, circa 1490
(Cat. no. 34)

visions such as that of Gregory to fortify their proofs. By the twelfth century, references to "transubstantiation" appear frequently in ecclesiastical documents, a refinement of thinking that began almost three centuries earlier.[21]

The emerging interest in Christ's humanity—as an element of technical debates like that surrounding the transubstantiation, and as an aspect of broader devotional outlooks—turned increasing attention to the Virgin as an object of interest and imitation. Symbolized and venerated as an immaculate vessel, the Virgin's most significant role was as the first witness to Christ's incarnation. Her humanity anchored Christ to earth and, as the person nearest to God, she was an exemplar for those who aspired to a life of piety.[22] A number of thirteenth-century theologians took up her cause in their works and described her role in Christ's life, countless books were dedicated to her, and Annunciation imagery proliferated.

An interesting textual example can be found in the *Meditationes Vitae Christi*, written by a Franciscan friar in 1300 for a nun belonging to the Poor Clares and comprised largely of extracts from the sermons of Saint Bernard of Clairvaux, the twelfth-century founder of the Cistercian order. Here the Virgin's role as mother and caretaker is itself the devotional model, and the devotee is exhorted to engage in active meditation:

> Kiss the beautiful little feet of the infant Jesus who lies in the manger and beg His mother to offer to let you hold Him a while. Pick Him up and hold Him in your arms. Gaze on His face with devotion and reverently kiss Him and delight in Him. Then return Him to the mother and watch her attentively as she cares for Him assiduously and wisely, nursing Him . . . and remain to help her if you can.[23]

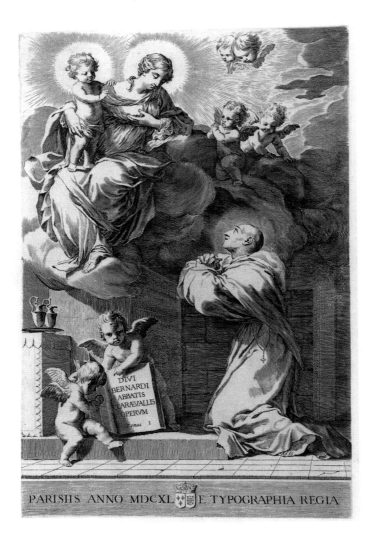

FIG. 41

Italian, Frontispiece to
*Divi Bernardi Abbatis
Claraevallis Operum*, 1640
(Cat. no. 48b)

Bernard's prescriptions for devotion were extremely influential in late medieval spirituality and retained currency well after the Reformation, as the Smart Museum's frontispiece to a late eighteenth-century edition of the *Divi Bernardi Abbatis Claraevallis Operum* indicates (FIG. 41). Here we see one of Bernard's particularly successful attempts to mimic Christ: according to tradition, the saint's ardent prayers resulted in a miraculous instance of lactation in which he was suckled by the Virgin. This image combines two points of Bernard's theology: his unwavering belief in devotion as elemental to piety and his insistence on the centrality of Mary's role as mediator.

The objective of worship based on intense visualization was to bridge the gap between quotidian activity and ecstatic vision. Devotional literature explained the practices of private devotional immersion, so that meditation could occur outside organized worship. Many prayer books included in this exhibition offer images suggesting that piety and meditational practice could conjure up a vision like the one Bernard experienced. The idea that laypersons could participate in the mystic process on their own time and by their own instruction was fairly revolutionary. Books of Hours owned by the nobility provided precise calendrical prayer schedules for laypersons who wanted to emulate clerical cycles of observance; they sometimes included images of people engaged in meditation. Used primarily as private devotional items, illuminated prayer books were often personalized through the inclusion of

portraits of their owners. On a page of the Flemish *Prayerbook of Margaret of Croy* (FIG. 42) from the mid-fifteenth century, Margaret kneels in prayer. She looks up from her open prayer book (presumably this very volume) to *see* the fruits of her meditation: she has conjured up the *Pietà*. The richly decorated, abstract background of gold filigree might signal the atemporality of this vision and help the viewer to read the image as testimony to a mystical experience located halfway between this world and the next. Margaret's robe spills over the painted frame to indicate that she inhabits the space of the book as well as the space of the vision.

Since meditation as it was prescribed by the Church required visual cues, those who could not afford an illuminated prayer book or a portable altar had to depend on more modest media. Supporters of the *devotio moderna* sought a more egalitarian religious practice, one that could include such worshippers. This cult of the imitation of Christ was a reform movement begun in the late fourteenth century in the Netherlands by Geert Grote and first practiced by a lay group, the Brothers of Common Life. Disciples of this philosophy, which attained widespread currency in the fifteenth century, were dissatisfied with a Church hierarchy that they felt had obscured the true principles of Christianity. They sought to return faith to the people by opposing clerical corruption and promoting means by which the individual could determine his or her own path to salvation. In connection with this goal, they promoted more available and affordable devotional tools.

Printed imagery, relatively economical and open to mass production, satisfied this demand particularly well. The first printed devotional images were single-leaf woodcuts,

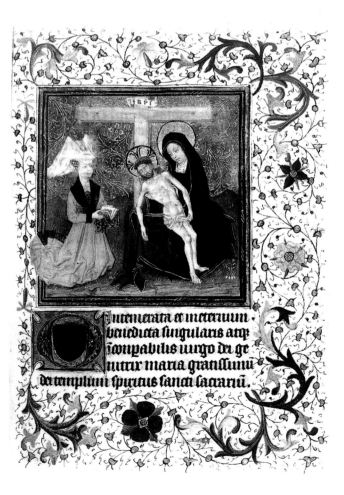

FIG. 42
Flemish, *Prayerbook of Margaret of
Croy: Margaret before the Pietà*,
circa 1435–1450
(Cat. no. 39)

sold as mementos to laypersons visiting pilgrimage sites. In the late fifteenth century, several brotherhoods, such as the ascetic Brothers of Common Life, controlled their own presses from which many block books emerged. Perhaps the most important and most successful early producer of printed devotional material was Albrecht Dürer. Printing broadened Dürer's popularity beyond that enjoyed by almost any artist before him; at the same time, a religious print in every house (as Cusa had advocated) gave everyone the means of capturing the attention of God.

But did the type of intercession sought through the use of prints differ substantially from the devotion of affluent classes that could afford lavish prayer books? The change heralded by early printmaking may represent a theoretical shift from the deposit of the image's power in its role as a sacred original, like a relic, to the power of the image conveyed by the form it represented.[24] As multiples, these objects were not regarded as sacred originals, perhaps not even as works of art, and they were not preserved as such.[25] Their primary functions were practical: to present a mnemonic device for the worshiper as a visual cue for prayer, and to offer an image before which one could perform indulgences for the remission of sins.

While the diffusion of imagery by the printing press satisfied those who promoted freer, more personalized devotional practices, it worried more rigid supporters of the Catholic Church (who promoted orthodoxy via controlled worship) and Protestants concerned with idolatry. Indeed, some sixteenth-century Reformers tried to outlaw most religious imagery, citing the biblical injunction against graven idols in Exodus 20. A fair number of fervent Protestants vandalized Catholic churches in Germany, Switzerland, and the Netherlands.[26] Catholics and moderate Protestants who clung to their images claimed that their worship was directed to the prototype rather than the image itself. In an interesting analysis of this very issue, the twentieth-century critic Walter Benjamin maintained that the profusion of mechanically reproduced imagery dilutes the ritual aura or cult value of the original image.[27]

The example of the relic helps to illustrate Benjamin's point. A relic's aura derives from the fact that only one of its kind exists and that its uniqueness cannot be replicated (although counterfeit relics of the *vera icon*, manifold splinters of the True Cross, and other such replicas did attract worshippers whose cultlike practices the Reformers found threatening to true belief). But the print, which could not make a claim to aura because no "original" ever existed, sustained a degree of comparative innocuousness in the eyes of the Reformers: a print depicting Christ would thus be less likely to encourage idolatrous veneration than a sculpture or painting of the same subject. Dürer's beautiful print of the *sudarium* might be admired in this context (FIG. 36). As a print, it participates in a more "popular" form of devotion, yet its subject is firmly rooted in Catholic observances. Dürer's powerful illusion of relief—of Christ's face emerging from the flat surface of the paper and the imagined veil—gives the substance of a three-dimensional relic to this relatively accessible devotional object, while retaining its status as a reproduction.

As the example of Dürer shows, prints actually served the Reformation's theoretical aims even as some of their authors remained devout Catholics.[28] The *Death of the Virgin* (FIG. 43) and *Descent from the Cross* (FIG. 44) are taken, respectively, from the *Life of the Virgin*, a book dedicated to the abbess of the Poor Clares convent, and the *Small Passion*, a thirty-seven-page visual history of man's salvation from the Fall to the Last Judgment. Both books were printed in Nuremberg in 1511 for ecclesiastic use and have texts by Benedictus Chelidonius, a monk and humanist scholar. Unlike the single-leaf woodcut that stood on its own, these images form part of a narrative series. Essentially a story told in pictures, the temporal sequencing of images would have discouraged the pure engagement celebrated by medieval meditation.[29] Unlike the parity between text and image exhibited in the illuminated

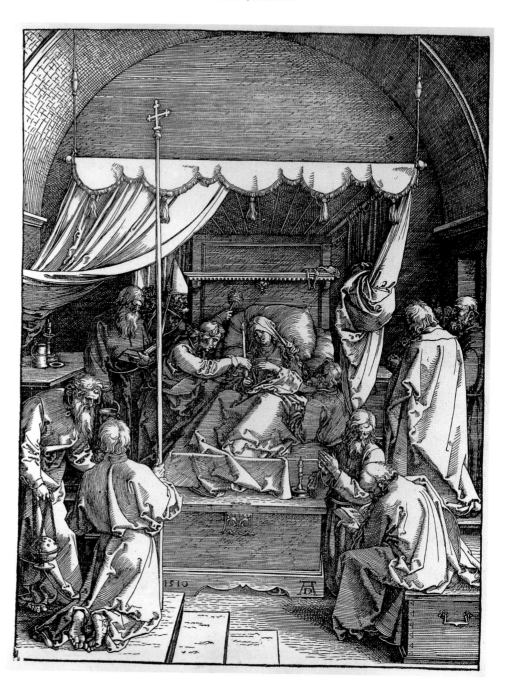

FIG. 43

Albrecht Dürer,

Death of the Virgin,

1509–1511

(Cat. no. 51b)

manuscript, in Dürer's series the image acquired new prominence and changed viewing practices. As Cynthia Hall has argued, Dürer effectively severed the link between text-based devotional imagery and meditative practices that had been in place for centuries. Once the artist assumed the burden of visualization, the devotee's role became passive.[30] The Reformers unquestionably applauded the closure of the interpretative gap in devotional practice.

While moderate Protestants saw the positive value of religious imagery and worked to establish an acceptable place for it in devotional practice, more extreme factions made their views known. The waves of iconoclasm that shook northern Europe—in the late 1520s in

FIG. 44
Albrecht Dürer,
Descent from the Cross,
1509–1511
(Cat. no. 51a)

Switzerland, in the wake of Zwingli's decree to remove and destroy church idols, and in 1566 when Netherlandish peasants revolted to protest the wealth, and in particular the expensive images, of the Church—encouraged some artists to turn to less public, and therefore less vulnerable, forms of art making. Because any art spied by a radical Reformer with an axe or a torch was in jeopardy, it made sense for art to be portable. Prints were one such genre; medals were another, and some German artists enthusiastically turned to this medium.[31] Hans Reinhart the Elder struck the Smart Museum's elegant silver medallion (FIG. 45 / COLOR PLATE 7) for Johann Friedrich, Duke and Elector of Saxony, who was best known as an ardent Luther sympathizer. Some of Reinhart's designs are based on the work of the painter Lucas Cranach, who worked in Johann Friedrich's court; both artists were engaged in the effort to systematize acceptable Protestant iconography.[32] Medals usually fea-

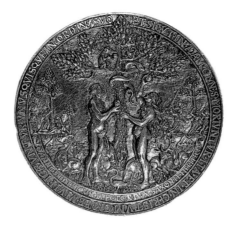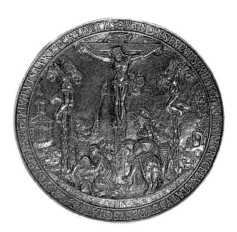

FIG. 45

Hans Reinhart the Elder,

Medallion: The Fall of Man

(obverse), *The Crucifixion*

(reverse), 1536

(Cat. no. 7)

ture portraits of their commissioners, but the Smart's example presents religious scenes: the Crucifixion and the Fall of Man. How, then, is it distinctly Protestant? Part of the answer lies in the scenes it does *not* represent. Reformers avoided Marian imagery and the portrayal of saints other than the Apostles and the Evangelists; in their eyes, these popular themes of late medieval devotion had inspired the wrong kind of veneration.[33]

The imagery and inscription on Reinhart's medal have a distinctly Protestant tone. The obverse features the Fall of Man, and sets several narrative episodes in an Eden so lush that the fullness of nature competes with Adam and Eve for attention. While its rich flora and fauna demonstrate a growing artistic preoccupation with the merits of this world, its natu-ralistic details are laden with symbolism: the monkey, fox, snake, and pig are emblems of sin, the unicorn of purity; the ox, ass, and rooster have biblical references; the swan may symbolize the Resurrection. The Garden of Eden was a popular subject among Reformation artists because it afforded the opportunity to focus on the individual's inner and outer natures, on mankind's own potential for either sin or salvation.[34] The Latin inscription sur-rounding Reinhart's image is taken from the words of Saint Paul and reads, "For as in Adam all die, even so in Christ shall all be made alive, every man in his own order."[35] Coupled with the Crucifixion portrayed on the reverse, Reinhart's image of the Fall portends the salva-tion of mankind through Christ's death and emphasizes the individual nature of this salva-tion. The words at the foot of the Crucifixion scene, "My hope is in God," reinforce the main tenet of Luther's theology: that salvation rests in individual faith alone.[36]

This theological outlook encouraged a personal approach to devotion, something that provoked the suspicions of the Catholic Church. So too did the reproducibility of prints and medals, which further encouraged unchaperoned devotional practices. Prints produced under Protestant influence suggested that the viewer could invoke a unidirectional view of God in any situation, away from either the ecclesiastical environment of communal liturgi-cal celebration or the more remote spatial retreat that was required for personal contem-plation. This meant that one's vision of God became a truly human vision with physiologi-cal dimensions and limitations, an experience much more direct than the kind of out-of-body meditative leap encouraged in previous decades by elegantly mounted body parts, lavishly carved and painted altarpieces, or even gilt-edged prayer books. The unmooring of objects from more formal contexts of ritual practice also freed them from subject matter that was determined by regularized worship. For the most part, Protestants shunned the visionary hypertext that surrounded Catholic images and, toward the end of our period, dispensed altogether with the sorts of powerful images that an earlier Christian Church had found both comforting and necessary.

NOTES

1. Matthew W. Dickie, "Fathers of the Church and the Evil Eye," in Henry Maguire, ed., *Byzantine Magic* (Washington, D.C.: Dumbarton Oaks, 1995), 12.

2. Eunice Dauterman Maguire, Henry P. Maguire, and Maggie J. Duncan-Flowers, *Art and Holy Powers in the Early Christian House* (Urbana: Krannert Art Museum and University of Illinois Press, 1989), 6.

3. This assumption is based on similar plaques found with portions of mirrors still intact. See Ann Marie Yasin, catalogue entry in *The Classical Collection*, ed. G. Ferrari, C. M. Nielsen, and K. Olson (Chicago: The David and Alfred Smart Museum of Art, 1998), 112–13.

4. Kurt Weitzmann, ed., *The Age of Spirituality: A Symposium*, exhib. cat. (New York: The Metropolitan Museum of Art, 1979), 388.

5. W. L. Hildburgh, "Psychology Underlying the Employment of Amulets in Europe," *Folk Lore* 62, 1 (March 1951): 240.

6. H. P. Maguire, *Art and Holy Powers,* 6.

7. Dickie, 11. Jerome maintains that Christ forbids the maleficent arts under the proscribed deeds of the flesh (Galatians 5:18). Jerome and Basil agree that Christians do have reason to fear those envious of their good fortune. Good fortune was understood to mean things that provoke envy—prosperity, beauty, or virtue—and the Church fathers identified these qualities with the devil.

8. Eusebius, *Sermo VII: De Neomeniis et Sabbatis et de non observandis avium vocibus,* cited in Dickie, 28.

9. Henk W. van Os, *The Art of Devotion in the Late Middle Ages in Europe, 1300–1500* (Princeton, N.J.: Princeton University Press, 1994), 164.

10. Veronica is mentioned in Voragine's *Legenda Aurea,* Rogier of Argenteuil's Bible, and also in the Apocryphal gospels of Nicodemus. See Joseph Leo Koerner, *The Moment of Self-Portraiture in German Renaissance Art* (Chicago: University of Chicago Press, 1993), 81.

11. The first appearance of this type was in Roger of Argenteuil's Bible. On the Veronica image, see Hans Belting, *Likeness and Presence: A History of the Image before the Era of Art,* trans. Edmund Jephcott (Chicago: University of Chicago Press, 1994), 215–24.

12. See the introduction by Evelyn Underhill in Nicholas of Cusa, *The Vision of God,* trans. Emma Salter (London: J. M. Dent, 1928).

13. Cusa, 3 ff.

14. Cusa, 37–38.

15. Cusa, 47: "Thou art to be seen of all creatures, and Thou seest all; in that Thou seest all, Thou art seen of all; for otherwise creatures could not exist, since they exist by Thy seeing."

16. Cusa, ch. 13.

17. *From Van Eyck to Bruegel: Early Netherlandish Paintings in the Metropolitan Museum of Art,* exhib. cat., ed. Maryan Wynn Ainsworth (New York: The Metropolitan Museum of Art, 1998), 96.

18. Belting, 209.

19. Michael Camille bases this assumption on the probability that an image of the angel Gabriel was paired with the Virgin Annunciate, who appears in a roundel above the principal figure group; see *The David and Alfred Smart Museum of Art: A Guide to the Collection,* ed. Sue Taylor and Richard A. Born (New York: Hudson Hills Press, 1990), 34.

20. Barbara G. Lane points out that a painted explanation of the miracle lodged in transubstantiation would help to convey the meaning of the miracle to the parishoner; see *The Altar and the Altarpiece: Sacramental Themes in Early Netherlandish Painting* (New York: Harper and Row, 1984), 79.

21. The Roman Council of 1079 appears to be the first official document to explain the nature of the conversion.

22. Van Os, 14.

23. Cited in van Os, 13.

24. Christiane Andersson and Charles Talbot, eds., *From a Mighty Fortress: Prints, Drawings, and Books in the Age of Luther, 1483–1546* (Detroit: Detroit Institute of Arts, 1983), 173–75.

25. Cynthia Hall, *Before the Apocalypse: German Prints and Illustrated Books, 1450–1500*, exhib. cat. (Cambridge, Mass.: Harvard University Art Museums, 1997), 16.

26. For a good summary of the concerns and history of Reformation iconoclasm, see David Freedberg, *The Power of Images: Studies in the History and Theory of Response* (Chicago: University of Chicago Press, 1989), 378 ff.

27. Benjamin refers to aura as the distance between the object and its authenticity: destroying aura is analogous to "prying an object from its shell." Walter Benjamin, as quoted in Leo Braudy, ed., *Film Theory and Criticism*, 5th ed. (New York: Oxford University Press, 1999), 735.

28. Erwin Panofsky, "Comments on Art and Reformation," in *Symbols in Transformation*, exhib. cat. (Princeton, N.J.: The Art Museum, 1969), 24. Dürer's proto-Protestant sympathies are illustrated by words he wrote on the reverse of a print in protest of the "blasphemous act of Mariolatry," in critique of Michael Ostendorfer's image of the Schöner Maria around which a cult had formed.

29. Humanism increasingly came to influence devotional imagery and change its character.

Dürer collaborated with humanists such as Chelidonius, whose poem accompanying the *Life of the Virgin* refers to Mary as the divine mother of Phoebus and to Joseph as a second Daedalus. See Rainer Schoch in *Gothic and Renaissance Art in Nuremberg, 1300–1550* (Munich: Prestel-Verlag, 1986), 302.

30. Hall, 23–24.

31. Stephen K. Scher, *The Currency of Fame: Portrait Medals of the Renaissance* (London: Thames and Hudson, 1994), 24.

32. For a discussion of Reinhart's relationship with Cranach, see Scher, 284.

33. Panofsky, 10. The Reformation's prohibitions against certain types of iconography invited new subjects.

34. Craig Harbison, *Symbols in Transformation: Iconographic Themes in the Time of the Reformation*, exhib. cat. (Princeton, N. J.: The Art Museum, 1969), 16.

35. I Cor. 15:22–23.

36. Smart Museum archives and Judith Ann Testa, catalogue entry in *The David and Alfred Smart Museum of Art: A Guide to the Collection*, 40.

DIVI
BERNARDI
ABBATIS

Pious Journeys:
Exhibition as Course

The exhibition *Pious Journeys* did not simply provide students in an art history class on late medieval pilgrimage with objects for study. It lent substance and shape, born in large measure out of the concept of the show and the nature of the display, to the course structure and sequence. With its stunning installation, it constituted a special place to which students returned throughout the quarter, mindful of their own developing insights and changing attitudes on each occasion. Standing within the blue walls of the exhibition area, members of the class were provoked to engage references from lectures and readings in immediate and varied ways. My task was to help them sustain a lively relationship to the exhibition, one in which they felt themselves physically implicated, aware of their movements and sensitive to the ways in which personal circumstances affected the nature of emotional and aesthetic response. Toward that end, we viewed a movie about pilgrimage together; the centrality of that activity to the work of the course is revealed in the student essay that follows these remarks.

The objects selected for the exhibition were organized into three principal sections, which grew out of and were amplified by the graduate student essays published in this catalogue. The first of these, "Personal Piety," included early pilgrimage tokens, jewelry, and small altarpieces of later centuries, and encouraged us to think about the use of sacred objects in a private context. A related display on "Private Devotion: The Place of the Book," employed illuminated manuscripts, printed books, and small works on paper to consider how shifting technologies—specifically the growing role of printing—impacted personal relationships with religious imagery. The exhibition's second thematic grouping, "Sacred Liturgies," included books, altarpieces, a processional cross, and objects for priestly vestment. It investigated the ways in which objects ordered and controlled worship in a more public context. The final section, "Holy Communions," considered the presentation of Christ's body and the bodies of the saints—in paintings, reliquaries, manuscripts, and other media—and investigated how these presentations shaped Christian worship. In moving from exhibition to text, we have rearranged these sections to accomodate catalogue readers as opposed to museum visitors.

The course was also divided into three sections with related, if not absolutely parallel, themes. The first segment, "From Legend to Liturgy," established the visual, historical, and religious background for pilgrimage study. Our attention focused on the sacred sites of the Holy Land toward which the earliest pilgrims, the Emperor Constantine's mother Helena and the Aquitanian nun Egeria, journeyed in the fourth century. We read accounts of their travels, analyzed the sites they would have seen as these have been defined by architectural historians, and explored the function that souvenirs like the Saint Menas ampulla (FIG. 17) played in the reconstruction of remembered devotional activity. Because Mass as celebrated

LINDA SEIDEL

in Jerusalem constitutes a mimetic re-enactment of Christ's final journey, we looked at liturgy as topographical movement, studied Passion imagery on painted and ivory panels in the exhibition as stages in a spiritual pilgrimage, and considered the crafting of eucharistic vessels and clerical costumes as forms of devotional activity. Important medieval texts by Theophilus and Abbot Suger were our guides in this last endeavor, and objects in the show, such as the processional cross (FIG. 7) and the chasuble (FIG. 3/COLOR PLATE 2), provided us with relevant examples of pious workmanship. The highlight of this segment of the course was the opening of the Smart Museum exhibition at which Ad Astra, an a cappella group composed of graduate and undergraduate women, performed religious (and some secular) music of the later Middle Ages in the resonant space of the museum lobby.

"Pilgrimage as Rite of Passage" shifted attention from journey as idea to journey as action. The historical focus of this segment of the course was the cult of relics in the tenth through twelfth centuries, with territorial attention centered on France and Spain. Professor Patrick Geary's presentation to the class complemented our reading of his work on "sacred thefts" of saintly remains and provided an exceptional opportunity to see scholarship as a lively undertaking. Through him, the students encountered an inquiring mind in action in the immediate context of issues that they were simultaneously learning to question. The pedagogical focus of this unit was the application of theoretical principles to visual material. We first read several chapters from Arnold van Gennep's short, classic study of spatial and temporal movement as rites of passage, a text that has had important ramifications for cultural anthropologists (see Selected Bibliography, p. 88); then we viewed a classic mid-twentieth-century Hollywood "western," John Ford's *Stagecoach*, the tale of a group of mid-nineteenth-century travelers and their journey through the badlands of the American Southwest in search of safe harbor. The students were challenged to analyze some aspect of the movie—such as the characters' territorial passage or emotional transformation—in the terms set forth in the reading. This exercise, which brought together viewing and reading practices, allowed members of the class to define for themselves the personal expectations and interpersonal interactions that shaped the film characters and their experiences of what was, effectively, a spiritual journey. Beyond the film, our visual focus was the series of richly decorated churches built along the pilgrimage roads in France and Spain leading to the shrine of Saint James at Santiago de Compostela. We studied floor plans and architectural elevations, metal body reliquaries like the one of the head of Saint Theobald in the exhibition (FIG. 18), and, in particular, the splendid portals on which liturgical processions and other forms of pilgrimage-related imagery were represented in monumental, narrative form. Efforts to understand the ways in which the reception of imagery is shaped by personal needs and perceptions were abetted by the lessons learned from the movie.

The final section of the course, "Surrogates and Substitutions," considered prayer as a form of pious pilgrimage. We studied the reading and meditational activities of Benedictine monks and came to see their cloistered practices as a form of pious journey in place. The exquisite carvings of the enclosed spaces in which they lived and worked provided them with prompts for prayer and transformed their constructed and isolated domicile into an image of the holy land wherein their every action was truly taken in Christ's footsteps. Study of reading practices, stimulated by the papers and presentation of Paul Saenger from the Newberry Library, focused our attention on the role played by illuminated manuscripts in fostering meditational activities among the laity, particularly young women, to whom the personal prayer books known as Books of Hours were frequently offered as marriage gifts. In the case of very wealthy recipients, a portrait of the owner at prayer might be incorporated into the opening page of a text (FIG. 42); in the case of young brides, a special prayer

to assist in childbirth might be inserted further along. These marks of personal identity effectively enabled luxurious parchment books to stand in for their owners when the latter were unable to attend to their devotional duties. And when they were engrossed in its pages, associations brought to mind by the names of the jeweled objects and brilliant flowers depicted in the bountiful borders would have helped them recall and ruminate on their prayers (FIG. 50).

The thread running through all segments of the course involved notions of the body: we analyzed pilgrims' physical engagement with the territories through which they pass, examined the collection and display of body fragments in the heyday of the relic trade, and explored the sounds of monastic prayer and the often highly charged personal relationship between books and their owners. Images of Christ's body, beautifully set out in one of the larger sections of the exhibition, emphasized the centrality of that theme in Christianity and enhanced our appreciation of the spiritual significance of mimetic art.

During the last weeks of the quarter, the undergraduates in the class, working under the tutelage of a graduate assistant, Matthew Shoaf, met with Matt and me to discuss the essay they would contribute to this exhibition catalogue. The springboard for this project would be the midterm paper each had written on *Stagecoach*. In reading those papers, I had looked ahead to the subsequent assignment and pointed out, in my remarks, issues that I thought could be employed in the development of that project. I now encouraged students to think about how to go about this: for example, how to work from ideas about the visual and thematic significance of motherhood in the movie, a theme several had addressed, to an appreciation of depictions of motherhood (i.e. the Virgin and Child) in the context of travel to a sacred shrine. Similarly, the image of a rehabilitated fallen woman (Mary Magdalene) could serve as a catalyst for transformation in the life of repentant pilgrims just as it did for the sinners in the stagecoach. Students drew on class readings and discussions in their consideration of these materials. Because many of them were interested in issues of gender and female sexuality, a lecture by Professor Peggy McCracken of the University of Michigan on body, blood, and the cult of the Holy Grail provided another productive lens through which they were able to focus their ideas. They met to share insights with each other, read the essays written by the graduate students (and published here) as models of what they might create, and consulted with Matt Shoaf about details of their own arguments. In that way, their separate papers were constructed and then submitted at the end of the class. This was, I think, the hardest part of the project since the time frame was so short. Moreover, it left no time for us to plot out how the individual papers would come together. Because of the constraints of the University of Chicago's quarter system, that task fell to me. Out of the extremely thoughtful responses of the undergraduates, and inspired by the writings of two graduate students, Lauren Goldman and Simone Tai, I have crafted what follows. While my fingerprints are unquestionably all over the structure of the essay, every idea, even that expressed in the title, is lifted from one or another of the students' papers. If, earlier in the quarter, they could only base their thought on what they heard in class and were directed to consult, at the close of the course it was my turn to listen to them. I merely revised what they gave me to read, rephrased what I think I heard them trying to say.

At every stage, this project was a team effort, one that moved between theory and practice, insight and enactment. Each of the participants, among whom I include myself, profited immeasurably from interactions with others involved in the planning, design, and use of the show. The final essay project was no different. *Re*-presentation of the undergraduates' ideas has given me one more chance to teach the students in this exceptional class and, more importantly, one last occasion to learn from them.

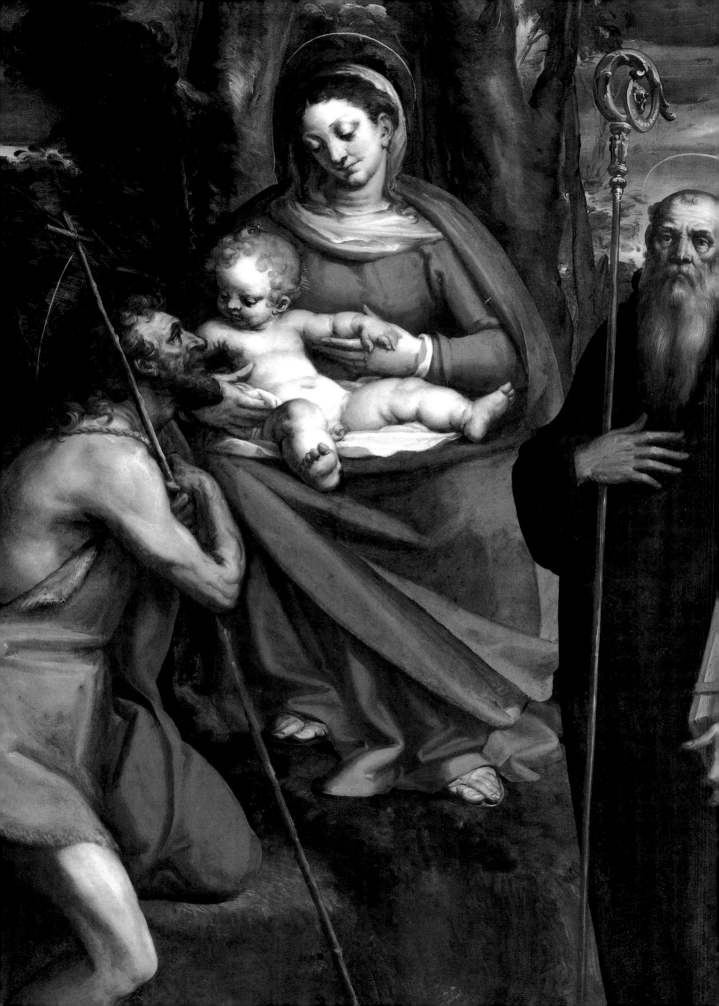

The Territories of Pilgrimage

In the Middle Ages, and still today, pilgrimages are journeys to special sites, taken for the purpose of purifying the soul and cultivating the spirit; they provide different forms of edification for their varied participants. As complex events imbued with multiple meanings, they involve many factors that must be taken into account in any effort to understand their power. First, the pilgrim's physical journey toward a designated shrine is marked by shared encounters; these are shaped by individuals met along the way and affected by the spaces through which the various participants move. Second, the personal needs that motivate the pilgrim to set out and

JENNIFER SARENE BERG, SIENNA BROWN, WEN-SHING LUCIA CHOU, MELATI LUCILLE GRANUCCI, TODD ANTHONY KOMOROSKI, ANN MARIE LONSDALE, RISHAM MAJEED, ANNA OHLY, PAMELA RABOY

the "baggage" that he or she brings along color the private experiences that accumulate *en route*; these constitute a less visible but no less significant passage.

The most evident physical markings of these inner and outer journeys and the theoretical relationship between them were sketched out in 1908 by the Belgian folklorist Arnold van Gennep in his classic work *Rites of Passage*, a cross-cultural analysis of temporal, spatial, and territorial movement.* Van Gennep's characterizations of boundary definitions, as well as his description of the notion of liminality—a space "betwixt and between," as anthropologist Victor Turner so gracefully summarized this concept—have entered into common parlance since the translation of the book into English in 1960. An equally classic work of a very different kind puts the principles that van Gennep defined into vivid, visual play in a way that clarifies them and makes them remarkably relevant and memorable.

John Ford's award-winning film *Stagecoach* (1939) follows a group of mid-nineteenth-century travelers, each of whom is differently invested in the journey, through a dangerous landscape against which their individual and interpersonal dramas are played out. As they move together toward a common goal, their outer and inner journeys repeatedly and overtly intersect so as to make us conscious of the ways in which deep-seated desires, unanticipated experiences, and unfamiliar places and objects collaborate in the transformation of behavior. The opportunity to "see" van Gennep's abstractions and precepts in play in an accessible manner assists us in applying these lessons to an analysis of the shifting boundaries of physical and personal space in other forms of individual and group movement, religious as well as secular.

Structurally, *Stagecoach* is divided into three distinct phases that recall, almost uncannily, the three stages of passage that van Gennep distinguished in his book. Activities attending each traveler's departure at the outset of the movie and at each of the intervening stops constitute *rites of separation* insofar as the passengers are explicitly loosened from the class distinctions and social settings that previously defined them. As the travelers become engaged with their companions in unanticipated ways, they participate in the *liminal* zone of unpredictability and reversal, where they are forced to reconsider their relations to one another; it is possible, in the stage of being "betwixt and between," for them to act outside of prescribed social norms and to establish new forms of contact and communication. Although the occupants of the stagecoach do not begin the journey with the spiritual goals we associate with religious pilgrimage, several of them find the passage toward their destination, Lordsburg, developing into a profound spiritual quest. At the end of the physical journey, the *reincorporation* of each traveler into the new community shows the particular inner transformations of character that have been achieved along the way.

FEMALE MODELS

In the film, two women occupy center stage throughout the stagecoach's long journey. One, Dallas, is a prostitute who has been booted out of town by a group of upright lady citizens; her unusual name sets her apart from the others and seemingly attaches her to a place to which she has a questionable connection. The second woman, Mrs. Lucy Mallory, is a young army wife from a refined Southern family who seeks to join her husband's unit in order to await the birth of their child. The women constitute moral and motivational poles. The reticent, modestly attired Mrs. Mallory—a sickly, genteel figure whom the male passengers attempt to protect—makes the trip against the advice of friends in order to be reunited with her husband. Dallas, enveloped in a ruffled dress that clearly offends standards of good taste, boards the coach without having any particular destination. One woman has a specific goal in mind; the other merely needs to get away. Whereas Lucy Mallory's pilgrimage to reach her unborn child's father involves

* See Selected Bibliography, pp. 88–90, for complete references to works cited.

a geographical goal, Dallas's journey takes her through the territory of her own identity. By assisting Lucy in the unexpected and ritually significant birth of the baby, Dallas, the unworthy and initially unrepentant whore, is transformed from vulgar outcast into saintly member of the group. For a while, she functions as the infant's sole caretaker, substituting for Lucy, who seems too weak and distracted to assume that responsibility. The presence of a crucifix on the wall of the birthing chamber unequivocally emphasizes the religious implications of the mothering role. These accrue to Dallas, distancing her from her former identity and contributing to a radical reformulation of her character.

The film's presentation of motherhood as a transformative event and powerful model of behavior provides a window through which to view and understand several of the images and objects displayed in the Smart Museum's *Pious Journeys* exhibition. One display area was devoted to private prayer books that featured, among other devotions, daily prayers known as the Hours of the Virgin, which focus on the birth of Christ. The significance of these prayers has been likened in importance by one scholar to the role played by the high altar in a Gothic cathedral (Wieck, p. 60). Female readers of these devotional texts would have viewed Mary through the referential framework of childbirth. One of the prayers for Lauds recalls the biblical story of the Visitation, in which Mary's older cousin Elizabeth recognizes the younger woman's pregnancy and deferentially touches her stomach; a depiction of the Visitation often appears above the prayer's opening words. In this story, the younger woman receives respect from the older one in contrast to more usual social hierarchies. Whereas age bestows a sense of dignity on people based on the progression of nature, a woman of any age who becomes pregnant is instantly "blessed"; she is thrust into the sacred realm and achieves a place of honor in the cycles of the natural world.

Repetition of Mary's principal activities—giving birth and caring for her child—constituted the fundamental model of behavior for medieval women. Mary was the Christian figure with whom ordinary women could most identify, whose struggle they could remember and contemplate, and whose activities they could best hope to emulate. Her image appeared in many places and many guises. Symbolically, she was the first altar, as she cradled the baby Jesus in her lap. In the life-size painting of the *Madonna and Child* by Luca Cambiaso (FIG. 46/COLOR PLATE 8), a large and imposing figure of Mary sits on an elevated throne holding Jesus on a white cloth upon her knees. The napkin on which he sits instantly recalls the altar cloth on which the Host is placed during the Mass, as is pointed out by Barbara Lane. An allusion to the altar with the consecrated wafer—understood literally by the faithful as the body of Christ—is thus layered onto the depiction of Mother and Child, so that the holy mother and the sacred altar are apprehended simultaneously as one.

The pious Virgin Annunciate, who often sits passively with a book in her lap and her hands folded neatly as she accepts the angel Gabriel's announcement of her miraculous destiny as the mother of God, occupied a prominent place in late medieval art. In the gabled upper portion of a small Sienese diptych panel (COLOR PLATE 6), for example, Mary appears in a pose that seems an illustration of Luke 1:38: "Behold, I am the handmaiden of the Lord." Among her many other roles, Mary was a model of pious fertility and childbearing, a topic that preoccupied devout women of the period. A number of pilgrimage shrines attest to this preoccupation.

Shrines believed to have miraculous properties associated with fertility, for example, are mentioned in *The Pilgrim's Guide to Santiago de Compostela*, a twelfth-century pilgrims' manual (see Melczer), and these may have had a special attraction for women even if they did not deal directly with human generation. One of these churches is dedicated to warrior saints Facundo and Primitivo. Flowers were said to have bloomed upon and around the spears that the two saints planted into the ground after battle, even though no seeds were present. This type of miracle signaled natural fecundity and growth, and could be meaningful for a woman hoping to become pregnant. Around 1250, at the church of the SS. Annunziata in Florence, a pilgrimage cult developed around a fresco depicting the Annunciation because the painting was said to have

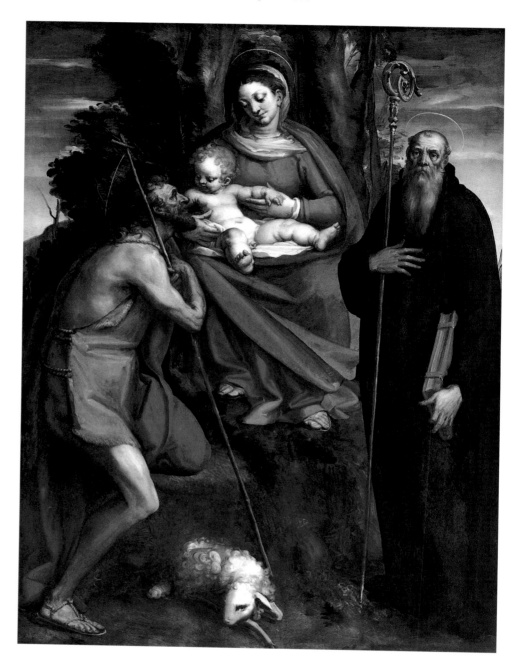

FIG. 46
Luca Cambiaso,
*Madonna and Child with
Saint John the Baptist and
Saint Benedict*, 1562
(Cat. no. 29)

been completed while the artist slept. This sign of miraculous activity was thought to facilitate the ability of newly married couples to have children, and they flocked to the site to venerate the image. In general, the particular miracles of a given shrine held out the promise that those who visited the site and were deemed worthy by the presiding saint might share in a similar experience.

In addition to the predominant role that Mary plays as Christ's mother, she also performs a compassionate role as co-redeemer alongside her son. On the Sienese panel, the Virgin appears again at the foot of the cross; bent in pain and crying, tormented by the death of her only child, she actively participates in the redemptive process. It is through the qualities that Mary demonstrates in her behavior toward Christ—specifically the maternal love that she displays at his birth

FIG. 47

Giles Rousselet

(after Jacques Stella),

frontispiece to

Exercita Spiritualia

S. P. Ignatii Loyolae, 1644

(Cat. no. 48a)

and death—that she is able to connect with the layperson, ultimately leading the devotee to a higher degree of spirituality. Mary also served as a guide for clerics by being a model of pious behavior. We see this quality displayed on the orphrey band that decorates a late sixteenth-century Italian chasuble, where an embroidered medallion presents the Virgin in an attentive, pious pose (FIG. 3/COLOR PLATE 2). This depiction provides not the illustration of a familiar Christian text or the portrait of a venerated matriarch, but an example of pious practice that the priest wearing the garment would gesturally imitate and initiate in the performance of the liturgy. The idea was to inspire others to similar behavior. In a mid-seventeenth-century frontispiece to a French edition of Saint Ignatius of Loyola's *Spiritual Exercises* (FIG. 47), the notion of the Virgin as inspiration is given literal expression, as she guides Ignatius in composing his treatise. Mary, as mother but also as spiritual role model, directs the saint in his piety.

As exemplar and guide, Mary is welcoming rather than intimidating. A group of children being led through the *Pious Journeys* installation one afternoon paused in front of a panel painting of the Virgin by Bernardino Fungai (COLOR PLATE 3). The painting portrays the Madonna's bodily assumption to heaven. A group of angels form an oval around the Madonna, one that resembles the shape of a womb; the painting can be imagined as portraying entry into the spiritual world as a kind of rebirth. One of the young girls in the group was asked to describe how she felt after looking at the painting. She concluded, after close observation, that she felt "safe." The parallels between the spiritual journey to piety and the earthly mother-child relationship

can also be perceived in the seventeenth-century frontispiece to the *Spiritual Exercises*. Just as the saint enters the fullness of the spiritual world because of the Virgin's motherly attention to him, so life on earth begins for a child through its mother. Throughout childhood, it is the mother who prepares the child for the journey of life that lies ahead. In this way, both secular life and spiritual devotion can be seen as pilgrimages with the mother as leader and companion.

One other set of objects in this exhibition evoked, in unexpected ways, the analogies between private spiritual exercises and the mother-child relationship: books designed to encourage vocalization. In the Middle Ages, reading often occurred aloud, even when it was an individual act; the visual mark on the page was a cue to oral performance. Reading and singing, then, were directly implied, and chanting—like that inspired by the large antiphonary on loan from the Newberry Library (Cat. no. 13)—was a sort of musical encoding of devotional expression. The regular vocal rhythms that we readily associate with liturgical exercises recall the central role a mother has in forming the way a child understands language and sound even before he or she can read or write. The inflection of a mother's voice determines the meaning that young ears gain from words; the practice of singing lullabies serves as a testament to the voice's soothing power and its ability to transport us emotionally. Similarly, the liturgical use of song and recitation provided devotees with a powerful, intimate connection with the spiritual realm. Speaking and chanting are elemental acts that recall our bonds to the most basic of human attachments—to the source of physical birth, the mother, and to the less tangible longings of the soul.

Because of her role in childbirth, the centrality of the mother (in a Christian context, the Virgin Mary) requires little explanation. But birth is a potentially transformational event for other individuals as well. In the movie *Stagecoach*, Dallas, the outcast prostitute, is redeemed through participation in the delivery of Lucy's baby; she is transformed from whore to wife, passing from the profane to the spiritual, if not fully sacred, sphere. Dallas's transformation likens her to the biblical figure of Mary Magdalene, whose initial deficiencies made her an attractive and accessible model for repentant Christians, serving, as van Os noted, "for instruction, veneration and remembrance" (p. 158). Mary Magdalene's close proximity to Christ during his Passion—she follows him from Bethany, where she washes his feet with her tears after he raises her brother Lazarus from the dead, to Jerusalem, where she is the first to see Christ after his resurrection—made her a model pilgrim. During Holy Week, when visitors to the Holy Land retrace Christ's last procession, they follow Mary Magdalene's footsteps as well. One of the most popular pilgrimage shrines during the Middle Ages was the church on a hilltop at Vézelay in France where, according to medieval legend, the Magdalene's relics came to rest. *The Pilgrim's Guide* describes the miracles that occurred there: "Thanks to her love, the faults of the sinners are here remitted by God, vision is restored to the blind, the tongue of the mute is untied, the lame stand erect, the possessed are delivered, and unspeakable benefices are accorded to many" (Melczer, pp. 104–5).

According to Jacobus de Voragine, the mid-thirteenth-century compiler of the *Golden Legend*, Mary Magdalene was known only by the name "the sinner" until she had contact with Christ; as the first to see the risen Christ, she was made "apostle to the apostles." In other words, she became a guide to others, as can be seen in the depiction of Christ's Passion on a small, exquisitely carved fourteenth-century ivory diptych (FIG. 1). The shape and size of the object, as well as the fact that it opens like a book, means that it could be held in the hands of the viewer and "read." This reading would consist of following the story as it moved from register to register, left to right and top to bottom. The first full register shows Christ's Entry into Jerusalem and the Washing of the Apostles' Feet, thus evoking the pivotal events at which Mary Magdalene was present—the raising of Lazarus at Bethany and the meal at the house of Simon, where she washed the Lord's feet with her tears—without actually showing her. In the depiction of the Crucifixion on the last register of the ivory, the Magdalene is positioned to the left of the cross, unshrinking and with her head uncovered. Her central position in this scene demonstrates her

FIG. 48

Installation of *Pious Journeys:*
Christian Devotional Art
and Practice in the Later
Middle Ages and Renaissance:
"Sacred Liturgies"

importance. If a person of so low a stature could achieve such proximity to Christ then so could an errant viewer, perhaps the owner of this very object. Mary Magdalene, whose own story provides examples of a physical journey as well as a personal pilgrimage, serves as the mediator between the worshiper and Christ; she provides a promising and accessible model for emulation.

The Magdalene also appears to the left of the cross in a very different type of object, a cast silver medallion by Hans Reinhart the Elder of 1536 (COLOR PLATE 7). To the right, directly opposite Mary Magdalene, is a small depiction of the open tomb from which Christ is emerging. Mary plays the dual role of being present at the Crucifixion and the Resurrection, the culminating events in the Christian story and the two most pivotal moments of her own pilgrimage. After the Resurrection she became Christ's appointed guide, "his apostle to the apostles." Reinhart's medallion, when carried by its owner, would have marked the bearer's every movement as taken in the footsteps of Christ and in emulation of the repentant sinner Mary Magdalene.

OBJECTS OF ATTENTION

Like pilgrimage itself, liturgical procession reenacts Christ's physical journey and reaffirms his spiritual one, and is marked by the stages of ritual passage. Objects play significant roles in defining the boundaries and goals of such ceremonies and in guiding participants' external behavior and personal fulfillment. A processional cross on view in this exhibition (FIGS. 7 and 48) would have been mounted originally on a staff and held high above a crowd, sanctifying the space through which the advancing file of clerics moved as they made their way to the altar of the church in imitation of Christ's own, final journey. The cross, held aloft for all to see and follow, separated the clerics' zone of movement from that of the congregants while providing visual focus for both groups' engagement with the unfolding events.

FIG. 49

Installation of *Pious Journeys:*
Christian Devotional Art and
Practice in the Later Middle Ages
and Renaissance:
"Holy Communions"

The material splendor of this cross, beautifully crafted of glistening gilt copper and silver and covered with finely modeled and engraved figures, would have attracted the gaze of onlookers, transporting their attention from the physical realities of this world to the greater splendors of the next. The three-dimensional, strongly modeled body of the gaunt, suffering Christ, cast in a dullish silver in contrast to the shimmering gilt surface of the vertical shaft, is attached to the cross by prominently protruding nails. The sight of Christ's swooning, pendant body would have reminded viewers of his physical torments and of his own movement toward the place of final sacrifice.

At the altar, toward which the cross was carried, this sacrifice would be re-enacted by the priest in the celebration of the Eucharist. A small image of the pelican piercing its breast to feed its offspring, visible immediately above Christ's head, signifies Holy Communion—the partaking of Christ's own blood and body in the form of the wine and the wafer. The imagery of the silver cross thus brings together the record and reality of historical event (Christ's death) with the timeless truth of theological message (his sacrifice to humankind); external and inner journeys are united in the imagery of its metal surfaces. Whether carrying or viewing the glittering object, clerics and congregants equally assumed the position of Mary Magdalene in other images we have seen: all were pious participants at the foot of the cross.

Whereas the cross represents the universal message of Christianity, the reliquary head of Saint Theobald (FIGS. 18 and 49) centers devotional activity on one holy figure, much as specific shrines focused on a particular saint. The sculpted silver head, with the human remains of the martyred holy man hidden inside, provides a physical image of the powerful agent whose assistance worshipers sought, either for their own physical healing or spiritual forgiveness or for that of loved ones. Spiritual pilgrims, like the riders of the fictive stagecoach we have been considering, had different personal reasons for undertaking their searches, which may have involved a visit to the relics of a local patron saint or entailed a much more arduous journey.

The reliquary head, with its differentiated inner and outer parts, expresses the dual nature of pilgrimage as both terrestrial and spiritual activity. The remains concealed inside the metal container secure the earthly traces of the saint's former existence and guarantee his presence at

THE TERRITORIES OF PILGRIMAGE

the site of the reliquary (church, shrine, or, in this case, museum). In contrast, the carefully chased metal encasement, with its hieratic frontality, gilt-encrusted skin, and fixed, staring eyes, projects an image of the holy figure as he might be imagined in the heavenly realm, which is the source of his supernatural power. Thus he is both "here," in terms of the relic within, and "there" in paradise, as his splendid material form suggests.

Details of design reinforce the palpable qualities of the saint's head and make it extremely captivating. Its substantial size and strong modeling, particularly in the hollowed cheeks and furrowed brow, immediately engage the viewer. Differences in surface texture, from the incised lines of the thickly modeled moustache to the lighter stubble of the beard, further enhance the sense of presence by conveying the appearance of a man of a certain, identifiable age. But the most compelling aspect of the head lies in the intensity of the hypnotically large eyes; they address the viewer directly, even confrontationally. In the Middle Ages, sight was understood to be a tangible force consisting of rays that projected from the eye of the observer. Here vision provides the link through which the holy powers of the saint surge into the viewer. Through sight, the communication that the spiritual seeker desires is finally achieved.

The territory of pilgrimage—both physical and spiritual—is a liminal one. Because it lies "betwixt and between" more clearly defined social, terrestrial, and personal spaces, people transgressing its boundaries are likely to be caught up in unfamiliar, even chaotic, circumstances and may find themselves engaged in new, revelatory experiences. In this landscape of nearly unlimited possibility, prayer serves as the familiar, stable guide, allowing pilgrims to recite familiar words however drastically the setting of their devotional activity might change. Books of Hours served this purpose in medieval times. Whether the owners' recitations occurred in the privacy of the home, in the context of local liturgical services, or during a journey to a distant shrine, the illustrations and visual cues provided by books, especially by personalized ones, inspired ritualized contemplation that helped organize and focus events and aided in their perpetual recollection.

The tiny size of many prayer books facilitated association and identification with the promises of the Church. Many miniature manuscripts fit into the hollow of the hand. In use, they were readily folded into the palm, the parchment skins on which the text and illustrations are inscribed converging with human flesh. The owner of the book might even have seen herself depicted at her devotions, assuring her of the book's protective power (FIG. 42). In an image of this sort, the worshiper is always at prayer, continually engaged in the activity that guarantees spiritual rewards. The prayer book thus functioned as an amulet; when carried on the body, as many smaller ones could be, diminutive books assured their owners of perpetual grace.

Prayer books sometimes served as repositories in which pilgrims stored souvenirs or tokens that they collected during their journey (Kaufmann, pp. 43–64). Imprints of insects, flowers, and pilgrims' badges have been observed in the margins of prayer books, suggesting that such objects, gathered during a pilgrimage and acting as markers of both literal and metaphoric movement, gained power through their identification with a specific moment and a particular place. Painted representations of such objects, depicted as though they were laid out flat on a book and pressed in its pages, are incorporated into countless manuscript borders where they act as surrogates for actual souvenirs (FIG. 50). They cue the reader to recollect places seen or imagined, providing devices by which the sanctity of ordinary things can be defined and remembered. Such tokens also had a symbolic role as reminders of the fluidity between the literal and the metaphoric, particularly in the context of spiritual concerns. For example, late medieval hagiographic legends attribute active roles to flowers in the performance of devotional activities. Different colors and types of flowers in the garland of Saint Barbara were said to necessitate particular quantities of prayer: a periwinkle cost thirty Our Fathers while a daisy cost a hundred (van Os, pp. 170–77). The various flowers in the margins of many fifteenth-century prayer books served to remind devotees of how many prayers were required to reach their spiritual goals.

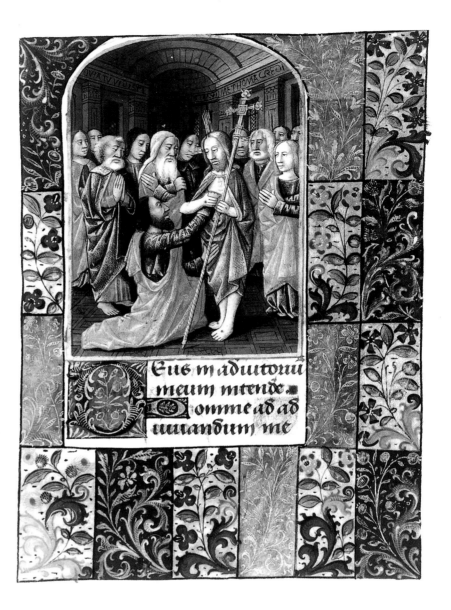

FIG. 50

French, Workshop of
Jean Bourdichon, *Book of Hours,*
Use of Rome: Doubting Thomas,
circa 1490
(Cat. no. 34)

PERFORMING PILGRIMAGE

In the course of a pilgrimage, individuals sharing a common goal unrelated to their normal routines and duties become part of a throng of interdependent people. The social realignment and commonality of feeling that emerges, no matter how transient, has been termed *communitas* by Victor and Edith Turner. We saw this phenomenon occurring in the movie *Stagecoach*, especially when the travelers made one of their stops and spontaneously redefined their roles in regard to the challenges at hand. Certain images of crowds in the *Pious Journeys* exhibition can be understood in terms of this notion, though less as depictions of social differences in the mundane sphere than as evocations of diversity within a shared human experience.

The group gathered at the Crucifixion in the Smart Museum's fourteenth-century Sienese panel painting (COLOR PLATE 6) is composed of Roman soldiers on the right and Christian figures on the left, including Mary Magdalene, who kneels at the foot of the cross and embraces it, with John the Evangelist and the Virgin Mary behind her; the anonymous faces of several other

holy women are also visible. These figures are distinguished by the different colors and treatments of their garments and by their distinctive props, yet each one looks up and fixes his or her glance on Jesus, lamenting his death and suffering. Their individual but shared understanding of the suffering of Christ, as rendered by their gesticulations and facial expressions, unites them as a group, focusing their attention—and ours—on the same scene.

In Donato Creti's seventeenth-century painting *Saint John the Baptist Preaching* (COLOR PLATE 1), a heightened sense of interaction has been constructed stylistically, with a light, airy brushwork that mutes distinctions between the individual figures. One man reaches out his hand to lift up that of another, enacting the words of Saint John, "Love one another as God has loved you." The most fully developed figure in the painting, apart from the Baptist, is that of a richly dressed Moor, who stands to the left of the saint. Observing a single, ethnically distinct figure melded into the diverse activities of milling mortals, the viewer, too, can be included in the scene.

Francesco Fontebasso's *The Martyrdom of Saint Catherine* (FIG. 16), depicts the moment when the saint is about to be beheaded at the command of Emperor Maxentius because of her efforts to convert his wife. A vast crowd is drawn to this event, as to Christ's crucifixion, by the suffering of a holy figure. Here the artist chose to render the scene with a large and diverse audience, ranging from celestial beings in heaven, men and women in different gowns, infants, and menacing Roman soldiers. All are painted in rich, vibrant colors and are positioned so that they encircle the saint in the fore-, middle-, and background. The soldiers sit on their horses, waving their flags to the right of the saint; directly above her an ensemble of angels plays trumpets and horns. Yet everyone seems frozen in time as they turn toward Catherine and gaze or point at the scene. The rendering of the surrounding architecture and the wheels of torture in light, muted colors makes them recede into the background, where they function merely as accessories to the scene of lively human interaction.

The unifying function of spiritual journeying came to life for one member of the "Pious Journeys" class who had the opportunity to participate in a short "pilgrimage" with a student religious group. A journey that began in silence, with highly independent participants moving on their own toward a common goal, changed as the day progressed. Group events, involving prayer and meals, encouraged participants to turn their attention to mutual interests and develop conversations with companions around those shared positions. These activities led to unanticipated, but frequently highly focused, interactions. When members of the group were asked why they had decided to participate in the pilgrimage, most of them talked about their need to get away from daily routine and devote themselves to private thoughts and reflections. This experience helped the class members understand firsthand how *communitas* is generated. The essence of *communitas* has been captured by painters like Creti, Fontebasso, and the anonymous Sienese artist through the depiction of carefully articulated individuals engaged in unifying ceremonial events. The representation of a diverse crowd, replete in identifiable and worldly traits, transports a viewer from her own recognizable surroundings to an elevated spiritual realm in which all people share a common truth.

In some cases, this common truth is arrived at through a shared sense of communion with a higher force; in others, it is discovered in the most basic human interactions. Among the multiple stories that unfold in the movie *Stagecoach* is a simple romance between the outcast Dallas and the outlaw Ringo Kid, who boards the coach after it has pulled out of town. The relationship between them, fostered by their exclusion from the rest of the group, blossoms as the coach travels through the wilderness of Apache territory with its physical dangers. Ringo, who has vowed to settle a personal score with a group of brothers in Lordsburg, accomplishes his ostensible mission upon arrival in town; his personal passage, however, has not found closure. In order to remain together, he and Dallas must escape the institutions that have condemned them. They continue to travel, crossing the border to Mexico, where they will be able to plan a new life together. Another journey begins.

One of the lingering images of the movie is the way in which the character of Ringo, played by a youthful John Wayne, introduces an ideal of heroic, heterosexual masculinity into the cadre of male misfits that populates the coach. A disheveled, drunken doctor, a puny whiskey salesman, a corpulent banker turned thief, and an oily professional gambler are an assembly of physical wretches and moral scoundrels, each of them a loner. Their weakness is all the more apparent in contrast to the figure of the tall, handsome, physically fit Ringo, whose bodily grace, agility, and physical appeal assure the well-being of the others while also indicating Ringo's own inner purity. His only error in society's traditional view is that he takes justice into his own hands, an act that life in the no-man's-land of the frontier openly sanctions.

The cowboy constitutes the modern version of the equestrian figure, a favorite image in ancient times, when it was employed to suggest bold courage in heroic battle and eternal glory in the journey to the afterlife. Its medieval counterpart was Santiago the Matamoro (Saint James the Moor Killer), whose legendary appearance on a white horse directed Crusaders to triumph against Muslim armies. The discovery of James's presumed relics at Compostela, in northwestern Spain, inspired the most important pilgrimage site known to medieval Europe, one that surpassed the fame of Peter's tomb in Rome. Throughout the centuries in which the Holy Sepulcher in Jerusalem was inaccessible to Christians, the church of Santiago was the most venerated miracle-working shrine in the West; it remains to this day a center of devotional activity and an important focus of pilgrimage.

The depiction of Christ as a mounted rider in scenes of the Entry into Jerusalem dates to the early years of Christianity, when the popular pagan image of the Roman emperor greeting his victorious armies was lifted from imperial iconography and appropriated for this new religious role. The Novgorod panel in the Smart Museum's collection (FIG. 8) provides a late example of this venerable pictorial tradition, in which Christ is shown in the familiar guise of an elevated, ideal earthly figure at the very moment at which he embarks upon the fulfillment of his divine mission. The termination of his terrestrial journey and the onset of his spiritual one are conflated in one familiar yet newly powerful image.

For the Christian faithful, Christ charted a model path for mortal men to walk from birth to death, demonstrating that life is the ultimate pilgrimage. Whatever our religious beliefs, his example might remind us that the time spent on earth is a liminal passage, an unpredictable journey through uncharted territory. It is made secure by the reassuring rules of framing social structures and their abiding truths. Christianity invites individuals to walk in Christ's footsteps, or in those of one of his more accessible holy companions, imitating their lives as closely as possible. As a way of translating this invitation into a vivid, effective guide, people create images after which they can model themselves and their actions. Ultimately, lived reality provides the visual inspiration for an idealized religious art and the grounds for its meaningful reception. Beautiful as well as homely images offer perpetual models for pious practices.

EXHIBITION CHECKLIST

All works are in the collection of the David and Alfred Smart Museum of Art unless otherwise noted. Height precedes width precedes depth in all measurements unless indicated; maximum dimensions are listed and measurements of books and manuscripts refer to page size. Checklist follows the general arrangement of materials as they appeared in the exhibition; sections I–III were on view in the Museum's Old Master Gallery; section IV was installed in the Joel and Carole Bernstein Gallery. Rotations of works on paper are indicated with a and b.

I. PERSONAL PIETY

1 Early Christian
Saint Menas Ampulla, 5th–6th century
Unglazed terra cotta with stamped decoration
H. 3 ½ in. (8.9 cm)
University Transfer, Early Christian Archaeological Seminar Collection of the Divinity School, 1988.41
Figure 17

2 Early Christian
Votive or "Evil Eye" Plaque,
5th–6th century
Unglazed terra cotta with traces of cold-paint decoration
5 ¾ x 3 ¾ in. (14.7 x 9.5 cm)
University Transfer, Early Christian Archaeological Seminar Collection of the Divinity School, 1988.39
Figure 33

3 Byzantine
Holy Rider Pendant, 6th–7th century
Bronze
1 ¾ x ⅜ in. (4.5 x 1 cm)
University Transfer, Early Christian Archaeological Seminar Collection of the Divinity School, 1988.56
(Not illustrated)

4 Byzantine
Holy Rider Pendant, 6th–7th century
Bronze
1 ¾ x 1 1/16 in. (4.5 x 2.7 cm)
University Transfer, Early Christian Archaeological Seminar Collection of the Divinity School, 1988.57
Figure 34

5 Byzantine
Pectoral Reliquary Cross, 9th–12th century
Bronze or brass
3 ½ x 1 ⅝ x ½ in. (9 x 4.1 x 3.5 cm)
University Transfer, Early Christian Archaeological Seminar Collection of the Divinity School, 1988.44
(Not illustrated)

6 Byzantine
Pectoral Reliquary Cross, 9th–12th century
Copper or high copper-content bronze
3 ¾ x 1 15/16 x ⅝ in. (9.5 x 4.9 x 1.6 cm)
University Transfer, Early Christian Archaeological Seminar Collection of the Divinity School, 1988.43
(Not illustrated)

7 Hans Reinhart the Elder
German, 1517–1561
Medallion: The Fall of Man (obverse),
The Crucifixion (reverse), 1536
Cast silver
Diam. 2 11/16 in. (6.8 cm)
Purchase, The Cochrane-Woods Collection, 1977.100
Figure 45 / Color Plate 7

8 German
Pendant: *Veronica's Veil* (obverse),
Madonna and Child (reverse),
15th century
Ivory and silver gilt (obverse), mother-
of-pearl and silver gilt (reverse)
Diam. 1 in. (2.5 cm)
The Martin D'Arcy Museum of Art,
Loyola University, Gift of Mr. and Mrs.
James Alsdorf, 26-79
Figure 35 (reverse not illustrated)

9 Russian
Pendant: *The Virgin's Descent into Hell* (?),
18th century (?)
Bronze
2 9/16 x 1 15/16 in. (6.5 x 4.9 cm)
University Transfer, Early Christian
Archaeological Seminar Collection of
the Divinity School, 1988.61
(Not illustrated)

10 Artists Unknown
Sculpture: German, Lower Rhenish
(Kalkar [?], Circle of Heinrich
Douverman, active 1515–1540)
Painting and frame: Netherlandish,
circa 1520
Polyptych: *The Crucifixion*, 1500–1520
Carved ash and fruitwood;
oil on wood panel
20 3/4 x 21 1/4 in. (52.7 x 54 cm)
The Martin D'Arcy Museum of Art,
Loyola University, Bequest of Thomas F.
Flannery, Jr., 1-84
Figure 39

11 Artist Unknown (formerly Master
of the Ovile Madonna and "Ugolino
Lorenzetti"), Italian, Sienese School
The Crucifixion, circa 1350
Tempera and gilding on wood panel
19 3/4 x 8 5/8 in. (50.2 x 21.9 cm)
Gift of the Samuel H. Kress Foundation,
1973.40
Figure 38/Color Plate 6

II. SACRED LITURGIES

12 Donato Creti
Italian, Bolognese School, 1671–1749
Saint John the Baptist Preaching,
circa 1690–1710
Oil on canvas
35 5/8 x 24 5/8 in. (90.5 x 62.6 cm)
Gift of the Samuel H. Kress Foundation,
1973.46
Figure 11/Color Plate 1

13 Basel
Antiphonary, Use of Basel, circa 1488
Printed book
15 x 10 1/2 in. (38.1 x 26.7 cm)
Courtesy of the Newberry Library,
Chicago
(Not illustrated)

14 French (Paris)
Missale itineratium, 1517
a. Angels with Symbols of the Passion
(p. 2)
b. Mass of Saint Gregory (p. 4)
Printed book
6 1/4 x 4 in. (15.9 x 10.2 cm)
Courtesy of the Newberry Library,
Chicago
Figures 22 and 27

15 Armenian
Book Cover: The Crucifixion, 1700–1750
Silver repoussé
8 1/6 x 6 1/8 in. (20.5 x 15.5 cm)
University Transfer, The Divinity School
of the University of Chicago, The Harold
R. Willoughby Collection, 1975.76
Figure 6

16 Artist Unknown, Veneto-Byzantine
School
Saint Jerome, 16th century
Oil on wood panel
34 x 26 1/2 in. (86.4 x 67.3 cm)
Gift of the Samuel H. Kress Foundation,
1973.41
Figure 5

17 North Italian
Processional Cross, 15th–16th century
(Cross: early 15th century; stem:
mid-16th century)
Cross: Copper gilt and silver beaten in
reverse over wood core; figure: partially
gilded cast silver
30 x 13 ¼ in. (76.2 x 33.7 cm)
The Martin D'Arcy Museum of Art,
Loyola University, Gift of Rev. Martin
D'Arcy, S.J., 5-70
Figure 7

18 Italian
Chasuble with Orphrey Band,
late 16th–early 17th century
Velvet with silver and gold embroidery
48 ¼ x 30 in. (122.6 x 76.2 cm)
Gift of Becky d'Angelo, 1992.34
Figure 3/Color Plate 2

19 French
Liturgical Comb, late 15th century
Carved boxwood
3 ¾ x 3 ⅝ x ½ in.
(9.5 x 9.2 x 1.25 cm), closed
Gift of Mrs. Ruth Blumka, 1982.5
Figure 2

20 Italian (Genoa)
Tabernacle, mid-15th century
Marble with gilding and polychrome
decoration
41 ¼ x 27 in. (104.8 x 68.6 cm)
Gift of the Samuel H. Kress Foundation,
1973.55
Figure 10/Color Plate 4

21 Bernardino Fungai
Italian, Sienese School, 1460–1516
*Madonna in a Mandorla Surrounded by
Angels,* circa 1480–1516
Tempera on wood panel
26 ¼ x 15 ⅞ in. (66.7 x 40.3 cm)
Gift of Elaine Lustig Cohen in memory
of Arthur A. Cohen, 1994.1
Figure 9/Color Plate 3

22 French (Paris)
Diptych with Scenes of the Passion of Christ,
circa 1370–1380
Elephant ivory
9 ¹¹⁄₁₆ x 9 ¾ in. (24.6 x 24.8 cm), open
The Toledo Museum of Art,
Purchased with funds from the Libbey
Endowment, Gift of Edward
Drummond Libbey, 1950.300
Figure 1

23 Artist Unknown, Russian, Novgorod
School
Triumphal Entry of Christ, 16th century
Oil on wood panel with wood cover
15 ½ x 11 ¹⁄₁₆ in. (39.5 x 28 cm)
University Transfer, The Divinity School
of the University of Chicago, The Harold
R. Willoughby Collection, 1975.69
Figure 8

III. HOLY COMMUNIONS

24 Italian (Savoy)
Reliquary Head of Saint Theobald,
1300–1450
Repoussé silver and silver gilt
14 x 15 x 7 ½ in.
(35.6 x 38.1 x 19.1 cm)
Minneapolis Institute of Arts,
Gift of Bruce B. Dayton, 83.73 a–c
Figure 18

25 Francesco Fontebasso
Italian, Venetian School, 1709–1769
The Martyrdom of Saint Catherine, 1744
Oil on canvas
16 ¹⁵⁄₁₆ x 24 ⅜ in. (43 x 61.9 cm)
Purchase, The Cochrane-Woods
Collection, 1978.23
Figure 16

26 Artist Unknown (formerly attributed
to Paolo de Matteis), Spanish (?)
The Martyrdom of Saint Stephen,
circa 1700–1750
Oil on canvas
10 13/16 x 13 15/16 in. (27.4 x 35.4 cm)
Purchase, The Cochrane-Woods
Collection, 1979.41
Figure 13

27 Alessandro Algardi
Italian, 1598–1654
Christ Falling beneath the Cross, circa 1650
Cast bronze
5 3/4 x 9 3/4 in. (14.6 x 24.8 cm)
Purchase, Gift of the Friends of the
Smart Gallery, 1980; 1980.48
Figure 14/Color Plate 5

28 Attributed to Antonio Gentili da Faenza
Italian, 16th century
Farnese Reliquary, circa 1550,
with later alterations and additions
Cast and wrought gilt silver, lapis lazuli,
rock crystal, enamel, and églomisé
H. 23 1/2 in. (59.7 cm)
Gift of the Samuel H. Kress Foundation,
1973.54
Figure 19

29 Luca Cambiaso
Italian, Genoese School, 1527–1585
*Madonna and Child with Saint John the
Baptist and Saint Benedict*, 1562
Oil on wood panel
55 x 40 5/8 in. (139.7 x 103.2 cm)
Gift of the Samuel H. Kress Foundation,
1973.50
Figure 46/Color Plate 8

30 Bartolommeo Suardi (called Bramantino)
Italian, Milanese School, 1465–1530
The Gathering of Manna, 1505–1506
Oil on wood panel
10 3/4 x 17 in. (27.3 x 43.2 cm)
Gift of the Samuel H. Kress Foundation,
1973.48
Figure 30

31 Bartolommeo Suardi (called Bramantino)
Italian, Milanese School, 1465–1530
The Raising of Lazarus, 1505–1506
Oil on wood panel
10 5/8 x 17 3/4 in. (27 x 45.1 cm)
Gift of the Samuel H. Kress Foundation,
1973.49
Figure 31

32 Artist Unknown, Italian, Bolognese or
Venetian School
Deposition, late 16th century
Oil on wood panel
12 x 9 in. (30.5 x 22.9 cm)
Gift of Mr. Ira Spanierman, 1981.58
Figure 21

33 North Italian
Dead Christ Attended by Angels,
circa 1525–1550
Cast silver-gilt bronze
3 9/16 x 4 1/2 in. (9 x 11.4 cm)
Purchase, Gift of Mrs. Thomas F.
Flannery, Dr. Burton Grossman,
Mr. Julius Lewis, Mrs. Ruth K.
McCollum, Mrs. Mary M. McDonald,
Mr. and Mrs. Leonard J. O'Connor,
and Mr. and Mrs. Frederick H. Prince,
1982.22
(Not illustrated)

34 French, Workshop of Jean Bourdichon
(circa 1457–1521)
Book of Hours, Use of Rome, circa 1490
a. Doubting Thomas (f. 79r)
b. Mass of Saint Gregory (f. 181v)
Illuminated manuscript
6 1/8 x 4 5/8 in. (15.6 x 11.8 cm)
Courtesy of the Newberry Library,
Chicago
Figures 50 and 40

35 Flemish (Bruges)
Book of Hours, Use of Salisbury, circa 1455
a. Christ's Wounds (ff. 91v/92r)
b. Man of Sorrows (f. 148v)
Illuminated manuscript
8 1/4 x 5 1/2 in. (21 x 14 cm)
Courtesy of the Newberry Library,
Chicago
Figures 29 and 28

36 Anton Raphael Mengs
German, 1728–1779
Study for the Rinucci Lamentation, 1779
Oil on wood panel
8 ⅝ x 6 ½ in. (21.9 x 16.5 cm)
Purchase, Gift of Mr. and Mrs. Eugene
Davidson, 1977.1
Figure 26

37 Juan Antonio Ribera y Fernandez
Spanish, 1779–1860
Deposition of Christ, circa 1800–1850
Pen and ink on laid paper
5 ½ x 9 ¼ in. (13.9 x 23.5 cm)
Bequest of Joseph Halle Schaffner,
in memory of his beloved mother,
Sara H. Schaffner, 1973.94
(Not illustrated)

38 Attributed to Juan Antonio Ribera y
Fernandez
Spanish, 1779–1860
*Study for the Central Group of the
Deposition of Christ*, circa 1800–1850 (?)
Pencil, pen and brush, ink and wash
on white laid paper
3 ⅞ x 5 ¼ in. (9.8 x 13.3 cm)
Bequest of Joseph Halle Schaffner,
in memory of his beloved mother,
Sara H. Schaffner, 1973.95
(Not illustrated)

IV. PRIVATE DEVOTION:
THE PLACE OF THE BOOK

39 Flemish
Prayerbook of Margaret of Croy,
circa 1435–1450, with additional
later illuminations
a. Margaret before the *Pietà* (f. 151r)
b. Flagellation of Christ (f. 9r)
Illuminated manuscript
7 ⅛ x 5 ⅛ in. (18.1 x 13 cm)
Courtesy of the Newberry Library,
Chicago
Figures 42 and 37 (f. 9r not illustrated)

40 Flemish (Bruges), Workshop of
Guillaume Vrelant (d. 1481)
Book of Hours, Use of Rome, circa 1475
a. Donor kneeling before Saint Peter
(f. 173v)
b. Martyrdom of Saint Sebastian
(f. 209v)
Illuminated manuscript
3 ¹⁵⁄₁₆ x 2 ⁹⁄₁₆ in. (10 x 6.5 cm)
Department of Special Collections,
the University of Chicago Library
(Not illustrated)

41 Netherlandish
Book of Hours, Use of Rome, early 15th
century
a. Saint Catherine of Alexandria
(f. 161v)
b. Donor before the Crucifixion
(f. 1v)
Illuminated manuscript
4 ¹⁵⁄₁₆ x 3 ½ in. (12.5 x 9 cm)
Department of Special Collections,
the University of Chicago Library
Figure 15 (f. 1v not illustrated)

42 French
Book of Hours, Use of Paris, circa
1500–1510
a. Crucifixion (f. 99r)
b. Donor before the *Pietà* (f. 112v)
Illuminated manuscript
7 ⅞ x 5 ⅛ in. (20 x 13 cm)
Department of Special Collections,
the University of Chicago Library
Figure 24 (f. 99r not illustrated)

43 French (Tours?)
*Book of Hours of Louis XI, Use of Saint
Victor of Paris*, circa 1480
a. Saint Victor on Horseback
(f. 130r)
b. Monastic Procession (f. 51v)
Illuminated manuscript
3 ¾ x 2 ⅝ in. (9.5 x 6.7 cm)
Courtesy of the Newberry Library,
Chicago
Figure 4 (f. 130r not illustrated)

44 French (Paris, Hardouin)
Book of Hours, 1526
a. Saint Christopher and Saint
Sebastian (ff. 190–191)
b. Saint Catherine of Alexandria and
Saint Barbara (ff. 198v/199r)
Illuminated manuscript
7 ¼ x 4 ¾ in. (18.4 x 12.1 cm)
Courtesy of the Newberry Library,
Chicago
(Not illustrated)

45 Italian (Venice), printed in German
Breviary, 1518
a. Prayers for Pentecost Eve
(ff. 253v/254r)
b. Virgin Mary in the Garden of Purity
(f. 306v)
Printed book
9 ¼ x 6 ½ in. (23.5 x 16.5 cm)
Courtesy of the Newberry Library,
Chicago
Figures 32 and 23

46 German
Himmlischen Palm-Gaertlein, 1748
a. Saint Barbara (f. 112)
b. Missionary Saint with Franciscan
Emblems (f. 16)
Handwritten book with printed
illustrations
6 ½ x 3 ¹⁵/₁₆ in. (16.5 x 10 cm)
Department of Special Collections,
the University of Chicago Library
(Not illustrated)

47a Albrecht Dürer
German, 1471–1528
Sudarium Displayed by Two Angels, 1513
Engraving
4 x 5 ½ in. (10.2 x 14 cm)
Gift of Mr. and Mrs. Richard L. Selle,
1979.1
Figure 36

47b Italian
Frontispiece to *De Imitatione Christi*,
1640
Engraving
19 ¼ x 13 ½ in. (49.1 x 34.6 cm)
Gift of Mrs. Eugene A. Davidson,
1974.55k
(Not illustrated)

48a Giles Rousselet (after Jacques Stella,
French, 1596–1675)
French (1610–1686)
Frontispiece to *Exercita Spiritualia S.P.
Ignatii Loyolae*, 1644
Engraving
19 ⅜ x 13 ⅝ in. (49.1 x 34.6 cm)
Gift of Mrs. Eugene A. Davidson,
1974.55c
Figure 47

48b Italian
Frontispiece to *Divi Bernardi Abbatis
Claraevallis Operum*, 1640
Engraving
19 ⅜ x 13 ⅝ in. (49.2 x 34.6 cm)
Gift of Mrs. Eugene A. Davidson,
1974.55l
Figure 41

49a Italian
Frontispiece to *Christianae Pietatis
Officia*, 1643
Engraving
19 ⅜ x 13 ⅝ in. (49.1 x 34.6 cm)
Gift of Mrs. Eugene A. Davidson,
1974.55i
(Not illustrated)

49b Raphael Vanni
Italian, 1587–1687
Saint Gertrude, 1625–1675
Engraving
19 ⅝ x 15 ⅛ in. (49.9 x 38.4 cm)
University Transfer from Max Epstein
Archive, 1967.116.174
(Not illustrated)

50a John Baptist Jackson (after Jacopo
Tintoretto, Italian, Venice,
1518/19–1594)
English, 1701(?)–1777(?)
The Crucifixion, 1740 (dated 1741)
Four-color chiaroscuro woodcuts
Panels I: 24 ¾ x 18 ¼ in.
(62.9 x 46.4 cm)
Panel II and III: 23 ⅞ x 18 ½ in.
(60.6 x 47 cm)
University Transfer from Max
Epstein Archive,
1967.116.144–146
Figure 12

50b1 Gaetano Stefano Bartolozzi
(after Giovanni Francesco Barbieri,
called Guercino, Italian, 1591–1666)
Italian, 1757–1821
Madonna and Child, 1790–1820
Stipple engraving
11 ½ x 7 ⁹⁄₁₆ in. (29.2 x 19.2 cm)
University Transfer from Max
Epstein Archive, 1967.116.127
(Not illustrated)

50b2 Ludolph Büsinck
German, 1590–1669
Saints Mark and Luke, 1610–1660
Chiaroscuro woodcut
10 ¾ x 13 ¼ in. (27.3 x 33.7 cm)
University Transfer from Max
Epstein Archive, 1967.116.100
(Not illustrated)

51a Albrecht Dürer
German, 1471–1528
Descent from the Cross from the *Small
Passion* series, 1509–1511
Woodcut, block (trimmed)
5 ⅙ x 3 ¹³⁄₁₆ in. (12.8 x 9.7 cm)
University Transfer from Max
Epstein Archive, Gift of the
Carnegie Corporation, 1927;
1967.116.101
Figure 44

51b Albrecht Dürer
German, 1471–1528
Death of the Virgin from the *Life of the
Virgin* series, 1509–1511
Woodcut
12 ¹⁵⁄₁₆ x 9 ⁹⁄₁₆ in. (32.9 x 24.3 cm)
Gift of Mrs. Sylvia Sights, 1976.42
Figure 43

52a Lambert Hopfer
German, active 1520–1530
The Entombment of Christ, 1520–1530
Etching
5 ½ x 3 ⅞ in. (14 x 8.8 cm)
University Transfer from Max
Epstein Archive, 1967.116.102
(Not illustrated)

52b Maria Katherina Prestel
German, 1747–1794
Holy Family, Saints, and Onlookers,
1781
Relief print with etching
7 ¹³⁄₁₆ x 6 ¹⁄₁₆ in. (19.9 x 15.4 cm)
University Transfer from Max
Epstein Archive, Gift of Pierre
Beres, 1976.145.265
(Not illustrated)

SELECTED BIBLIOGRAPHY

ANDERSSON, CHRISTIANE, AND CHARLES TALBOT, EDS.
From a Mighty Fortress: Prints, Drawings, and Books in the Age of Luther, 1483–1546. Detroit: Detroit Institute of Arts, 1983.

BARNET, PETER, ED.
Images in Ivory: Precious Objects of the Gothic Age. Detroit: Detroit Institute of Arts, and Princeton, N. J.: Princeton University Press, 1997.

BARTRUM, GIULIA.
German Renaissance Prints, 1490–1550. London: British Museum Press, 1995.

BECKWITH, SARAH.
Christ's Body: Identity, Culture and Society in Late Medieval Writings. London and New York: Routledge, 1993.

BELTING, HANS.
Likeness and Presence: A History of the Image before the Era of Art. Translated by Edmund Jephcott. Chicago: University of Chicago Press, 1994.

BROWN, PETER.
The Cult of the Saints: Its Rise and Function in Latin Christianity. Chicago: University of Chicago Press, 1981.

BYNUM, CAROLINE WALKER.
Fragmentation and Redemption: Essays on Gender and the Human Body in Medieval Religion. New York: Zone Books, 1991.

BYNUM, CAROLINE WALKER.
The Resurrection of the Body in Western Christianity, 200–1336. New York: Columbia University Press, 1995.

CARRUTHERS, MARY.
The Craft of Thought: Meditation, Rhetoric, and the Making of Images, 400–1200. Cambridge: Cambridge University Press, 1998.

DAHL, ELLERT.
"Heavenly Images: The Statue of St. Foy at Conques and the Signification of the Medieval 'Cult Image' in the West." Acta 8 (1978): 175–91.

FRAZER, MARGARET ENGLISH.
"Medieval Church Treasuries." The Metropolitan Museum of Art Bulletin 43, no. 3 (Winter 1985/86): 20–37.

FREEDBERG, DAVID.
The Power of Images: Studies in the History and Theory of Response. Chicago: University of Chicago Press, 1989.

GEARY, PATRICK J.
 Furta Sacra: Thefts of Relics in the Central Middles Ages. Revised edition. Princeton, N. J.:
 Princeton University Press, 1990.

GENNEP, ARNOLD VAN.
 Rites of Passage. Translated by Monika B. Vizedom and Gabrielle L. Caffee. Introduction
 by Solon T. Kimball. Chicago: University of Chicago Press, 1960.

HUGHES, ANDREW.
 Medieval Manuscripts for Mass and Office: A Guide to Their Organization and Terminology.
 Toronto and Buffalo: University of Toronto Press, 1982.

JENNINGS, JR., THEODORE W.
 "Liturgy." In *The Encyclopedia of Religion.* Edited by Mircea Eliade et al., vol. 8, 580–83.
 New York: Macmillan, 1987.

JUNGMANN, JOSEF A.
 The Mass of the Roman Rite: Its Origins and Development. Translated by Francis A. Brunner.
 Revised by Charles K. Riepe. Westminster, Md.: Christian Classics, 1980.

KAUFMANN, T., AND M.R. KAUFMANN.
 "The Sanctification of Nature: Observations on the Origins of Trompe l'Oeil in
 Netherlandish Book Painting of the Fifteenth and Sixteenth Centuries." *The J. Paul Getty
 Museum Journal* 19 (1991): 43–64.

KAY, SARAH, AND MIRI RUBIN, EDS.
 Framing Medieval Bodies. Manchester and New York: Manchester University Press, 1994.

KIECKHEFER, RICHARD.
 Unquiet Souls: Fourteenth-Century Saints and Their Religious Milieu. Chicago: University of
 Chicago Press, 1984.

KOERNER, JOSEPH LEO.
 The Moment of Self-Portraiture in German Renaissance Art. Chicago: University of Chicago
 Press, 1993.

LANDAU, DAVID, AND PETER PARSHALL.
 The Renaissance Print, ca. 1470–1550. New Haven, Conn.: Yale University Press, 1994.

LANE, BARBARA G.
 The Altar and the Altarpiece: Sacramental Themes in Early Netherlandish Painting. New York:
 Harper and Row, 1984.

MACDONALD, A.A., H.N.B. RIDDERBOS, AND R.M. SCHLUSEMANN, EDS.
 The Broken Body: Passion Devotion in Late Medieval Culture. Groningen: Egbert Forsten,
 1998.

MAGUIRE, EUNICE DAUTERMAN, HENRY P. MAGUIRE, AND MAGGIE J. DUNCAN-
 FLOWERS.
 Art and Holy Powers in the Early Christian House. Urbana: Krannert Art Museum and
 University of Illinois Press, 1989.

MELCZER, WILLIAM.
 The Pilgrim's Guide to Santiago de Compostela. New York: Italica Press, 1993.

METROPOLITAN MUSEUM OF ART.

From Van Eyck to Bruegel: Early Netherlandish Paintings in the Metropolitan Museum of Art. Edited by Maryan Wynn Ainsworth and Keith Christiansen. New York: The Metropolitan Museum of Art, 1998.

METROPOLITAN MUSEUM OF ART.

Gothic and Renaissance Art in Nuremberg, 1300–1550. Munich: Prestel-Verlag, and New York: The Metropolitan Museum of Art, 1986.

OS, HENK W. VAN.

The Art of Devotion in the Late Middle Ages in Europe, 1300–1500. Princeton, N. J.: Princeton University Press, 1994.

OUSTERHOUT, ROBERT, ED.

The Blessings of Pilgrimage. Urbana: University of Illinois Press, 1990.

RUBIN, MIRI.

Corpus Christi: The Eucharist in Late Medieval Culture. Cambridge: Cambridge University Press, 1991.

SAENGER, PAUL HENRY.

A Catalogue of the Pre-1500 Western Manuscript Books at the Newberry Library. Chicago: University of Chicago Press, 1989.

SWANSON, R.N.

Religion and Devotion in Europe, c. 1215–c. 1515. Cambridge: Cambridge University Press, 1995.

TURNER, VICTOR, AND EDITH TURNER.

Image and Pilgrimage in Christian Culture: Anthropological Perspectives. New York: Columbia University Press, 1987.

VIKAN, GARY.

Byzantine Pilgrimage Art. Washington, D.C.: Dumbarton Oaks, 1982.

VORAGINE, JACOBUS DE.

The Golden Legend: Readings on the Saints. Translated by William Granger Ryan. 2 vols. Princeton, N. J.: Princeton University Press, 1993.

WEITZMANN, KURT, ED.

The Age of Spirituality: A Symposium. New York: The Metropolitan Museum of Art, 1979.

WIECK, ROGER S., ED.

Time Sanctified: The Book of Hours in Medieval Art and Life. New York: G. Braziller in association with the Walters Art Gallery, Baltimore, 1988.

WILKINSON, JOHN, INTRO. AND TRANS.

Jerusalem Pilgrims before the Crusades. Warminster: Aris & Phillips, 1977.

ZIKA, CHARLES.

"Hosts, Processions and Pilgrimages: Controlling the Sacred in Fifteenth-Century Germany." *Past and Present* 118 (February 1988): 25–64.

WITHDRAWN

N 7824.4 .C5 D38 2001
Seidel, Linda.
Pious journeys